SECRET SHEFFIELD

Ian D. Rotherham, Melvyn Jones and Christine Handley

AMBERLEY

Acknowledgements

The authors would like to acknowledge the following individuals and organisations for allowing the use of illustrations: Chapeltown and High Green Archive, Roncraft Ltd, Sheffield City Council Local Studies Library, Frank Harvey, Peter Wolstenholme and Bob Warburton. They would like to thank Joan Jones for support in taking modern photographs and scanning illustrations. Many images are from the personal collections of Melvyn Jones and of Ian D. Rotherham. Museums Sheffield online resources are acknowledged for the notes on Charles Dixon.

First published 2016

Amberley Publishing
The Hill, Stroud
Gloucestershire, GL5 4EP

www.amberley-books.com

Copyright © Ian D. Rotherham, Melvyn Jones
and Christine Handley, 2016

The right of Ian D. Rotherham, Melvyn Jones
and Christine Handley to be identified as the
Authors of this work has been asserted in accordance
with the Copyrights, Designs and Patents Act 1988.

ISBN 978 1 4456 5310 5 (print)
ISBN 978 1 4456 5311 2 (ebook)

British Library Cataloguing in Publication Data.
A catalogue record for this book is available from the British Library.

Typesetting by Amberley Publishing.
Printed in Great Britain.

Contents

Introduction

Secret Sheffield has not been an easy book to write. This is not because it has been difficult to find suitable topics for inclusion but because of the immense amount of information and locations that have accumulated over the centuries and which needed sifting, selecting and brutal editing. We have also been all too aware of our illustrious forbears who have already uncovered and written about Sheffield's history; for example Joseph Hunter, Alfred Gatty, R. E. Leader, J. H. Stainton, Mary Walton, J. Edward Vickers and David Hey.

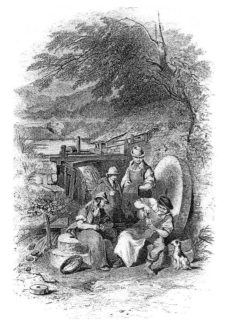

Left: A scene at a water-powered site on a Sheffield river.

Below: A winter panorama across the city centre, 2010.

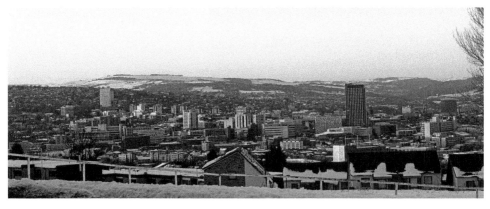

The result is both chronological and thematic across seven sections. The first of these, the early history of the city, covers the long period from the Mesolithic to the medieval, uncovering evidence of the first settlers after the last glaciation down to the establishment of the early town of Sheffield and religious holdings in the surrounding countryside. The second section is about the name-giving of Anglo-Saxon, Viking and Norman settlers, not only of settlements but also of streets and lanes, woods, hills and dales. The following section concerns monuments, not only those large monuments seen from a distance but also those that you need to crouch down to read and some you might not think were monuments at all – including two that are still alive! The fourth section is on industrial development, which goes back a very long way with Sheffield's cutlery industry first referred to in the tax returns of 1297 with *Robertus le coteler* – Robert the cutler – listed as a taxpayer. This is followed by a section on famous Victorian residents including many leading industrialists of the period along with musicians, actors, artists, poets, historians and children's writers. The penultimate section deals with little-known facts about transport and transport networks. The town's relative isolation has always been a sore point in Sheffield ever since Lord Lisle, one of Elizabeth's courtiers, writing to the 7th Earl of Shrewsbury in 1606 after the Earl's visit to the capital, hoped he'd arrived safely back in Sheffield which he believed was 'halfway to the North Pole'. Transport difficulties continued with the late arrival of the canal, a direct rail link to London and the short-lived Sheffield airport. The seventh and final section covers the subject close to the heart of every Sheffielder: its countryside. Sheffield is proud to be the greenest city in the country with extensive moorlands, ancient woodlands, beautiful river valleys and its very own 'lake district', and its countryside has no less a fascinating history than the commercial, industrial and residential parts of the city.

We hope our readers enjoy learning of the secret history of Sheffield and agree with us that George III was slightly prejudiced when he declared, in the year 1800, 'Ah Sheffield, Sheffield, damned bad place, Sheffield.'

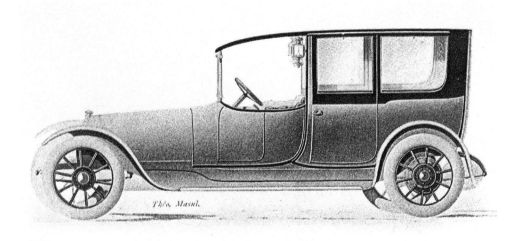

The 1913 Sheffield Simplex landaulette with coachwork by Pytchley (see Chapter Six).

1. Early History

The next time you go shopping in Meadowhall, sit in the traffic on Ecclesall Road or watch your favourite soap on television, take a minute to think back to our Sheffield predecessors 8,000 years ago, 2,000 years ago or 1,000 years ago. In fact, think of their daily lives over the last 10,000 years. At various places somewhere in what is now the City of Sheffield someone would have been doing what you are doing: gathering food supplies or acquiring clothing, making their way home, then sitting, eating or drinking and perhaps being entertained. There are more links between the past and the present than most people realise.

Hunter-gatherers

Much of the early evidence of people in the area is actually from the higher ground, what is today moorland, heath, or bog. Some of these finds hold signs and artefacts of Mesolithic and Neolithic (Stone Age) folk, our early ancestors. Some remains can be seen at sites where the peat has been removed by recent deep burns. In fact, the earliest evidence of humans in the Sheffield area comes from an excavation that took place at Deepcar, to the north-west of Sheffield centre, in the 1960s. It was a settlement site that dated from somewhere between 8,000 and 3,000 BC and was the first of its kind discovered in England.

This was a campsite of Mesolithic (Middle Stone Age) hunter-gatherers. These people did not live permanently on one site but were nomadic, surviving on animals that they hunted, fish that they caught, and berries, other fruits, nuts and roots they gathered. Living in a heavily wooded environment, mammals that were hunted included wild cattle, red deer, roe deer, horse, wild pig and beaver. Local rivers would have been teeming with fish, including trout and salmon, and of course, eels.

The site is located on a small hill overlooking the River Don, on the east side of the river opposite where Deepcar later grew up. The site consisted of the stone footings of a tent or hut that would have been covered with tree branches and skins, and beyond the hut there are what appear to be the footings of a windbreak. Such an elaborate arrangement suggests that the building was occupied for some period, possibly months at a time and on more than one occasion. This is emphasised by the remains of three separate hearths for fires.

What's more remarkable is that the site yielded more than 23,000 artefacts including the debris from working flint into weapons and tools. The characteristic artefact of the Mesolithic period is the microlith, i.e., a very small worked stone, most commonly of flint or chert (flint-like quartz). A microlith is in the shape of a very small arrowhead or barb and a number of these would have been glued into a wooden shaft with birch resin to make a multifaceted arrowhead, harpoon or spear suitable for hunting prey. Other flint artefacts were broader, rounder scrapers for cleaning flesh off skins.

Keeping Watch at Wincobank Hill

The Mesolithic hunter-gatherers were followed by the first farmers of the Neolithic – the Bronze Age and the Iron Age. The people of the Iron Age left remains of their fortifications, the most accessible being of an Iron Age hill fort on the summit of Wincobank Hill. This overlooks the lower Don valley less than 3 miles north-east of the city centre. The hill fort was probably built by tribes wishing to control the lower Don Valley. It consists of an oval defensive structure of just over 2.5 acres (1 hectare) surrounded by a single rampart with an external ditch. The material from the ditch was thrown up to form an outer bank. The grass-covered rampart is more or less complete except for three breaks. Excavations by Sheffield City Museum in 1899 and 1979 have shown that the rampart was originally built as a very substantial stone wall and was probably deliberately burnt with timber to fuse the stone into a more solid structure.

Using a scientific technique called radiocarbon dating it is possible to put an approximate date on some of the archaeological remains. Charcoal from burnt timber taken from the rampart in 1979 gives an approximate date of 500 BC, i.e. in the middle of the Iron Age. It has long been believed that the Wincobank fort was reoccupied by local tribes during the early Roman period to check the northern advance of the Roman armies. The site overlooks the major Roman fortress at Templeborough in Rotherham.

Quern-Cliff

The importance of cereal growing to early farming communities is indicated by the major quern-making industry at Wharncliffe and around the Loxley and Rivelin valleys to the north-west of Sheffield centre. Querns were hand-operated grindstones used for processing cereal grains into flour. The site at Wharncliffe is at the foot of the

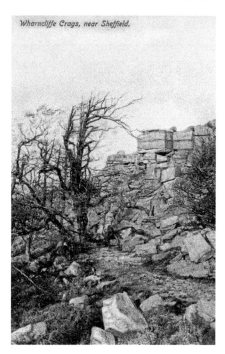

Wharncliffe Crags, near Sheffield.

Wharncliffe Crags in the early 1900s.

Crags (an outcrop of Wharncliffe Sandstone) and covers 72 hectares, one of the most significant sites in Europe. On-site evidence of querns of different types and sizes suggests that the 'factory' may have had its origins in the Bronze Age and that it was still active in the medieval period with its main phases of operation in the Iron Age and the Romano-British periods. Thousands of 'flat-disc' and 'beehive' querns in various stages of production survive on the site. The Anglo-Saxon name Wharncliffe is simply a corruption of 'quern-cliff'.

Roman Soldiers on the March

The nearest Roman military installation was the Roman fort at Templeborough dating from AD 54 and just 2 miles to the east of Wincobank hill fort across the River Don in Rotherham. It was built to accommodate 800 soldiers. By AD 69 the Romans had subdued the local tribe that controlled the land in a large region to the north and west of Templeborough, and built a road across this territory to the new Roman fort called Navio in the Peak District near the modern settlement of Brough near Hope. It is believed this Roman road came from the east along what is now Cricket Inn Road in Wybourn, crossed the Sheaf just above its confluence with the Don and climbed the spur past where the cathedral now stands, then up what is now Broad Lane and onwards in a WSW direction towards Navio. It was once believed that the paved trackway from Stanage Pole was part of this Roman road, and indeed this idea entered into local mythology. However, the track is now considered a Victorian route for carting millstone from the quarries on Stanage Edge, the Roman road passing some distance away.

Romano-British Farmers

Remains of the settlements occupied by the native, Celtic-speaking population during the Roman occupation, the descendants of local Iron Age farmers, can still be found in

Romano-British settlement site in Greno Wood.

local woodlands. They are in the form of ancient field systems where the Romano-British population cleared the woodland and laid out their fields. In Wheata Wood, at Grenoside, for example, the evidence is in the form of a series of ridges (called lynchets), low stone banks and the remains of a section of boulder wall. The features are severely eroded and covered by vegetation. In nearby Greno Wood there is another Romano-British site consisting of earth and stony banks forming the outlines of enclosures and rectangular and oval hut sites. At Ecclesall Woods, a major hill, fort has very significant rectilinear Romano-British fields laid out across its flank.

The Saxons and Vikings: What's in a Name?

After the departure of the Romans, the Angles and Saxons invaded from across the North Sea and settled in this country from the fifth century, reaching South Yorkshire in the early seventh century. They spoke what is called Old English, of which modern English is a much modified descendant, and most of our local Sheffield place names are Anglo-Saxon in origin. The Anglo-Saxon names of the Sheffield area tell us how wooded the region was. One of the most common place-name elements is 'ley', which means woodland or, more commonly, a woodland clearing. There are more than a dozen 'ley' place names in Sheffield including Birley, Cowley, Heeley, Loxley, and Totley. The place-name element 'field' does not mean field in the modern sense of the word but describes a large clearing in an otherwise well-wooded landscape and occurs in the names Bradfield, Ballifield, Ecclesfield, Hallfield and of course, Sheffield itself; Sheffield would then mean a treeless area beside the Sheaf, with 'sheaf' or 'sheath' meaning boundary.

Sheffielders are also surrounded by evidence of their Viking past. The word 'Viking' was the name given by the Anglo-Saxon population of England to the traders, raiders

Cowley Manor, Chapeltown (the word 'cowley' means a woodland clearing where charcoal was made).

and then settlers from Scandinavia in the late eighth and ninth centuries. They spoke in Old Norse and, like the Anglo-Saxons, they showed in some of their place names how well wooded the countryside was in which they were settling. Storrs, still a small village on the western Pennine-edge, is from the Old Norse word 'storth', meaning a wood, and 'thwaite', as in Butterthwaite, is the Old Norse equivalent of the Anglo-Saxon 'ley'. It means a woodland clearing with rich pasture. The 'thorpe' in Hackenthorpe, Hollythorpe, and Jordanthorpe is also an Old Norse word meaning a subsidiary village or hamlet founded as the offshoot of another, bigger village. The word 'gate' in Fargate for example, has nothing to do with gates but is an Old Norse word, 'gata', meaning a road or lane. The word gate for street must still have been part of the local vocabulary in the early Norman period when the town of Sheffield was established and Fargate simply means 'the street farthest from the castle'.

Domesday

When William the Conqueror's Norman clerks came to Sheffield in 1086 as part of his nationwide project to survey all his lands to ascertain exactly who owned every property and what they were worth, they did not find a town, but instead a series of villages and farms. Sheffield, Attercliffe, Ecclesfield, Grimeshou (later known as Grimesthorpe), Handsworth, Holdworth, Onesacre, Tinsley, Ughill, Wadsley and, Worrall were all named. Hallam (called Hallun) was also named and was said to contain thirteen unnamed 'berewicks' or outlying farms. It is also clear that all these settlements existed in a still heavily wooded landscape. Altogether, more than 20,000 acres of woodland were recorded within what are now the city boundaries, around 22 per cent of the total area. The woodland was described as *silva pastilis*, i.e. a wood pasture in which farm animals were allowed to graze and where farmers and their families were given permission by the lord of the manor to take wood and timber to meet their needs for building materials, firewood, tools, carts and ploughs.

A Town is Born

Sheffield began life as a town rather than a village under its Norman lords in the late eleventh century. The Norman town was established immediately to the south-west of the confluence of the rivers Don and Sheaf where, in the twelfth century, William de Lovetot built a motte-and-bailey castle with a stone and timber keep. The two rivers formed a natural moat to the Norman castle on the north and east. This motte-and-bailey castle, which had descended to the de Furnival family at the end of the twelfth century, was destroyed by fire in the second half of the thirteenth century during the baron's revolt and was replaced with a stone keep and bailey castle by Thomas de Furnival in around 1270.

The medieval market town of Sheffield grew up under the protection of the castle. In 1281, Thomas de Furnival was asked by a royal enquiry into the rights of landowners (called Quo Warranto – by what right), on what grounds he believed he had the right to hold a market in Sheffield. He replied that his ancestors had held it since the Norman Conquest. Fifteen years later, he put this right to hold a market on a more formal footing when in 1296 he obtained a royal charter. This was for a market every Tuesday and a fair at the Feast of Holy Trinity, which fell in either May or June.

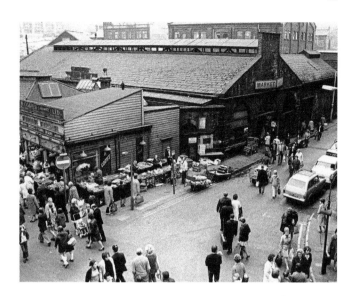

Sheffield market fifty years ago, where it had been for almost 1,000 years.

Beneath the castle walls, in a tight cluster of narrow streets, lay the oldest part of the town which had probably first emerged at the same time as William de Lovetots's timber motte-and-bailey castle. This included what is the modern Market Place, Haymarket (formerly called the Beast Market and before that the Bull Stake), Waingate (formerly called Bridge Street), Castle Green, Castle Folds, Dixon Lane, Snig Hill, and the now lost Pudding Lane, Water Lane, and Truelove's Gutter (which was also an open sewer).

From this central core beneath the castle walls, the town spread out in all directions. To the east along what became known as Dixon Lane, the way led to the River Sheaf where a stone bridge was built in 1596 and which led to the castle orchards. In 1666, on the southern edge of the latter, fifty years after the death of Gilbert, 7th Earl of Shrewsbury, a hospital in his name was erected for the housing of twenty-four poor townsfolk. To the south-west, the town extended along what is now the modern High Street, until the late eighteenth century known as Prior Gate. It contained properties belonging to Worksop Priory that provided a vicar for the parish church in return for one third of Sheffield's tithes. Beyond High Street was a lane called Fargate. Along both sides of High Street and the southern side of Fargate the evidence of the late medieval and early modern expansion of the town can still be seen. This is in the form of long narrow building plots sometimes separated by long alleys such as Change Alley, Mulberry Street and Chapel Walk. The long building plots, called burgess plots because they were occupied by the citizens (burgesses) of the town, reflect the desire to allow as many shop, workshop, and other workplace owners as possible to have a commercial frontage onto the main street. At the junction of High Street and Church Street at the south-eastern corner of the churchyard, stood the early town hall, the meeting place for the twelve Capital Burgesses, a body of men set up in 1554 by the 5th Earl of Shrewsbury to regulate the town's affairs. To the north of this was the medieval parish church, now the cathedral.

The stone castle survived until it was largely demolished in the late 1640s on the orders of Cromwell's government following the English Civil War. The castle had been garrisoned for the king until its surrender in 1644. Following demolition, it was plundered

by the local population for building stone and other buildings occupied the site. For these reasons, precise details of its layout have not survived. At its greatest extent the outer bailey is thought to have run south from the moat up the hill as far as the modern Fitzalan Square. Thomas Winder, who worked for many years in the Duke of Norfolk's estate office in Sheffield, put together a sketch map of the castle site based on old maps. The map shows a square hill on which the keep was located and the close relationship between the keep and the entry into the town across the River Don via Lady's Bridge.

It needs to be made clear that the myth of Sheffield founded on seven hills is just that, a myth. It grew up originally on one hill that stretched from the confluence of the rivers Sheaf and Don, up the hill towards High Street and Fargate. Other local places containing the name hill, such as Park Hill and Spital Hill, were outside of the early town. Of course, today the city does indeed spread over seven hills and their valleys.

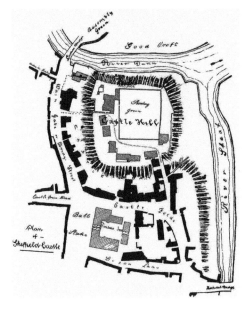

Thomas Winder's sketch map of the site of Sheffield castle.

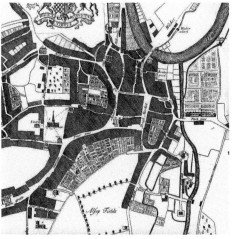

Ralph Gosling's map of Sheffield in 1736.

Sheffield Park

Park Hill is so named because this was part of the Norman lord of the manor's deer park, which stretched eastwards and southwards from the castle covering at its greatest extent 2,462 acres (nearly 1,000 hectares). It was 8 miles (13 kilometres) in circumference and was a typical shape, a rounded rectangle; a 'baronial castle park', with the castle located on the edge and the imparked area extending away from it like a large balloon. In a survey of 1637, the park was said to still contain 1,000 fallow deer. The 'Old Queen's Head' public house, which now stands in the Transport Interchange, was formerly a Tudor banqueting house in the deer park and called the Hall in the Ponds. In the late seventeenth century, there were still some magnificent ancient oaks in the deer park.

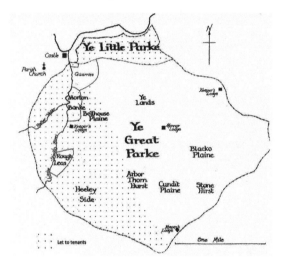

Sheffield deer park in 1637.

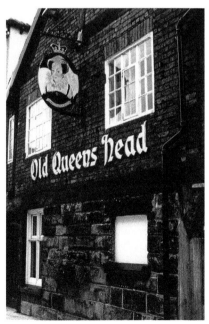

The Queen's Head, formerly the Hall in the Ponds.

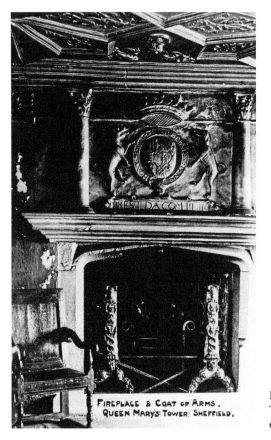

FIREPLACE & COAT OF ARMS,
QUEEN MARY'S TOWER: SHEFFIELD.

Fireplace and coat of arms at Queen Mary's Tower, the Manor Lodge (formerly in the middle of Sheffield Park) in the early 1900s.

Did You Know That?

Most deer parks were not created primarily for hunting, although hunting did take place in the larger parks. In deer parks, the deer were carefully farmed to provide for their owners a reliable source of food for the table. At the funeral of the 5th Earl of Shrewsbury in 1560, fifty does (female fallow deer) from the deer park were cooked and eaten. Hunting took place in royal forests, such as the nearby 'Peak Forest', and in their private counterparts, chases, hence the name Rivelin Chase where the lords of the manor of Hallamshire hunted the native red deer. Other chases in the region included Wharncliffe Chase.

Monastic Houses and Granges

Monastic ownership of land in areas now within the city of Sheffield was considerable. There were two monastic houses within what is now Sheffield's city boundary. At Beauchief, originally in Derbyshire, was a Premonstratensian abbey founded in around 1176. Now only the tower of the abbey church is visible together with outlines of its precincts, which included a deer park and fishponds. Beauchief Abbey also had at least seven granges, i.e. outlying economic units, in their case, farms where they grazed cattle,

sheep and goats. At least two of these were within the modern city boundaries, one at Strawberry Lee, 3 miles away on the edge of the moors and another at what is now called Fulwood Grange Farm, just over 3 miles to the north of Strawberry Lee. Beauchief Abbey was dissolved in 1537 and bought by Sir Nicholas Strelley, lord of the neighbouring manor of Ecclesall.

In 1161, around 7 miles to the northeast of Beauchief, properties in Ecclesfield parish were gifted by Richard de Lovetot, lord of the manor of Hallamshire, to the Benedictine abbey of St Wandrille in Normandy. By 1267, the monks of St Wandrille had built a priory behind Ecclesfield church. However, in 1337, the king confiscated lands belonging to foreign abbeys and priories and in 1386, Ecclesfield Priory and its lands were presented to a new priory in Coventry. The monks of Coventry rented out the land to tenants. This priory was dissolved in 1539 and its lands came into the ownership of the Earls of Shrewsbury and thus descended to the Dukes of Norfolk who held it until the early years of last century. A substantial part of the small priory building at Ecclesfield, most obviously the chapel with its undercroft, are incorporated into a private house which was sympathetically restored in 1889. It remains a residential property to this day. The priory had a grange called Woolley Grange, which coincides roughly with the present Concord Park and Woolley Wood. In Concord Park, there is a 'cruck barn' presently occupied by Sheffield City Council Parks and Woodlands staff, and which may have been erected in the later stages of the ownership of the grange by Ecclesfield Priory.

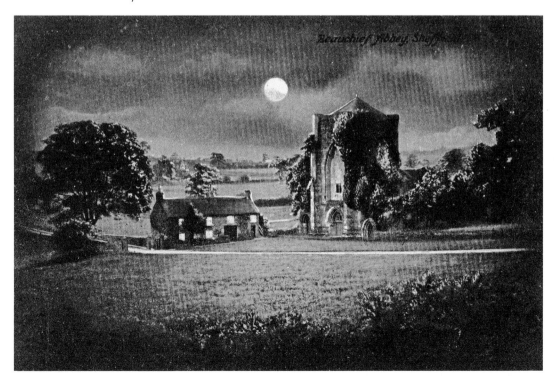

Beachief Abbey by mock moonlight, c. 1900.

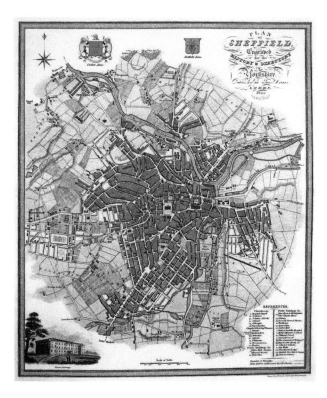

Sheffield map, 1822.

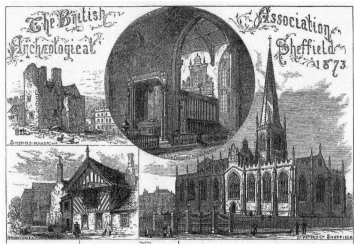

British Association visit to Sheffield in August 1873.

Did You Know That?

The place name Beauchief, now pronounced 'Bee-chif', is a Norman-French name and means 'beautiful headland', referring to the wooded hill beside the River Sheaf where Beauchief Abbey was located. Beauchief is derived from the same Norman-French word that gave Beachy Head its name.

2. Odd and Interesting Place Names

Every time we walk down a street, drive to work or to the shops, or hop on a bus or tram, we are surrounded by street names and our everyday conversations are peppered with the names of the city's suburbs and outlying villages. Yet many people don't give a second thought as to when they might have been coined, or what they mean.

If You Go Down to the Woods Today...

You may be in for a surprise. Many names in our now urban surroundings were recorded in documents for the first time in the medieval period but were often in use for centuries before they were first written down. It has already been pointed out, in Chapter One, that Sheffield lay in a well-wooded, rural landscape when the Domesday Book was compiled in 1086. Therefore, it is perhaps not too surprising that a number of the oldest names refer to wild animals. For example, Brocco Bank means badgers' bank, Yarncliffe in Yarncliffe House Farm in the Mayfield Valley means 'eagle cliff', and Woolley in the name Woolley Wood means 'a woodland clearing frequented by wolves'. Woodseats refers to the 'cottages deep in the wood'. In addition, the suburb name of Gleadless means a woodland clearing ('less' is a corruption of 'lees') frequented by kites (glead). Nor were insects ignored by our place-name givers. Between Firth Park and Sheffield Lane Top there is an area called Pismire Hill first recorded in 1548. 'Pissemyre' is a Middle English word meaning an ant!

Close by Psalter Lane is an old gennel which now drops down across the Porter Brook to Sharrow by the side of the old General Cemetery. It is said that originally there was another, older track to the east called the 'Old Walk' which in Sheffield parlance becomes 'T'owd Walk', and following Toad Walk, Frog Walk was the obvious name for the new footpath. Just don't expect any frogs.

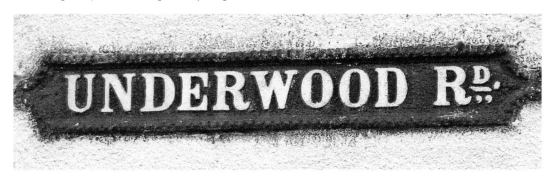

Underwood Road might be named after a Mr Underwood. However, the road was originally called Clarke Road after Reuben Clarke and was only renamed in 1902. This was perhaps derived from the proximity to the long-lost Smithy Wood on the site where the houses now stand.

Up Hill and Down Dale

Our Celtic, Anglo-Saxon, Viking and Norman ancestors had, between them, at least forty-five different words for hills, ridges, slopes and valleys. Indeed some writers have claimed that our ancestors had more words for hill and valley than the Inuits (Eskimos) have for snow. These names have passed down to us in the place names that cover the landscape. Margaret Gelling, the place-name scholar who died in 2009, established that none of these names for hills and valleys were synonyms, they referred to different sizes and shapes of hill and valley. With its hills and rivers, Sheffield is full of these hill and valley place names.

The most common of the hill names is of course hill itself, as in Spital Hill and Park Hill. Other fairly common words for hill are the Old Norse 'haugr' (hill or mound) as in Grenoside (quarried – *graefen*) hillside – *haugr*-side), Wincobank (Winca's hill slope) and the Old English 'hoh' which means the end of a ridge or a spur of land, as in Sharrow (boundary hill). There is also the Old English word *hlaw* that means a mound or slope and is found in the name Tinsley (Tynni's hlaw).

Different valley names are just as numerous. The word valley itself is most commonly used, as in Don Valley and Rivelin Valley. Also present is the word dale from the Old English 'dael' and the Old Norse 'dalr' as in Abbeydale and Whirlowdale. Less well known is the Old English word 'denu', which again simply means valley, and is used in the western parts of South Yorkshire as in Ewden (yew tree valley) and Agden (oak tree valley). Further to the west, on the moorland tops, there are the narrow steep-sided valleys that are called cloughs. In addition, separating each clough are the high, windswept Pennines referred to in innumerable place names as moors or mosses, the latter referring to particularly ill-drained moorland areas. Generally when a place is called 'moss', such

Conifer plantation around Agden reservoir in the 1950s (Frank Harvey collection).

as at Totley Moss west of Sheffield, it was a place with traditional peat turbary rights for fuel. There are also various names for the edges of high areas and the steep slopes leading down to the valleys below, for example edge as in Stanage (stone edge – which today gives us Stanage Edge i.e. Stone Edge Edge!) and cliff as in Shirecliffe (bright, steep hillside) and Cliffe Field (the field on the hill). At the far end of Shirecliffe is Scraith Wood, 'scraith' meaning a landslide or scree, and at the foot of Shirecliffe we find Neepsend ('hnip' is an Old English word meaning steep hill).

Boundary Names

Sheffield has always been on a significant boundary. Even today, the weather forecasters cannot decide whether it is in the East Midlands or North-East of England. In pre-Roman times, the area was on the border between the territory of the tribe known as the Brigantes to the north and west and the Corieltauvi to the east and south, hence the hill fort at Wincobank (see Chapter One).

The name 'sheaf' or 'sheath' in the name River Sheaf means boundary and its tributary the Meersbrook contains the name 'mere', also meaning a boundary. The Meersbrook rises at Gleadless Townend underneath the Red Lion public house. Here two other streams also rise, one which becomes the Moss Brook flowing south to Eckington and the other the Shire Brook flowing south-east into the River Rother. The Shire Brook is a comparatively recent name, being formerly the Der Brook – der being another name for boundary. The Meersbrook and Shire Brook are part of the same ancient kingdom boundary.

Whirlow, in the south-west of Sheffield means 'boundary mound'. All these boundary names coincide in part with the boundary between the Anglo-Saxon kingdoms of Northumbria

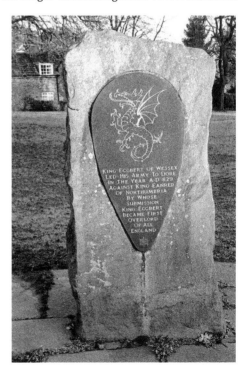

King Ecgbert Stone, Village Green, Dore.

to the north and Mercia to the south. This later became the boundary between Yorkshire and Derbyshire and the Sees of the Archbishop of York and the Archbishop of Canterbury. The name of the south-western suburb of Dore, which was originally in Derbyshire and was not incorporated into Sheffield until between 1929 and 1934, simply means door or passage, a name given because of its location in Mercia right on the boundary of Northumbria. It was here in AD 829, on the boundary between the two kingdoms, that the Northumbrians submitted to King Egbert of Wessex in order to avoid a military invasion. Dore Village Society placed a monument celebrating this event on the village green in 1968. What may be the remains of the ancient kingdom boundary were discovered by Paul Ardron nearly twenty years ago and follow the sinuous route of the Limb Brook just west of Ecclesall Woods.

Bending Routes

Most lanes, streets and roads acquired their names because of trades that were carried on there, or because of a place to which they led, or because of a family connection, but some got their names for peculiar geographical reasons. For example, near the top of Oughtibridge Lane leading from Grenoside to Oughtibridge is Whalejaw or Jawbone Hill. Some accounts suggest that actual whales' jawbones once stood at the top of the hill near the Birley Stone, but there is no firm evidence for this assertion. It is more likely that it got its name because the bend in the lane forms the perfectly symmetrical shape that would have been formed by erecting whale jawbones as an arch.

Another lane, this time in Ecclesfield, now with the common name of Mill Road, used to be called Dog Leg Lane because of the bend along its route.

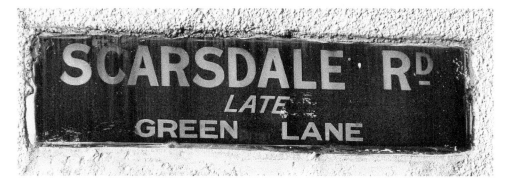

Sheffield's secret heritage lies all around if you look hard enough. The late Green Lane at Scarsdale – perhaps the lane to the green or an unmetalled trackway.

Did You Know That?

Boggard Lane, between Oughtibridge and Worrall, suggests that it was so named because it was haunted by a ghost. According to Joseph Hunter, local historian, these spectres (i.e. bogeymen) were said to be distinguished by their long teeth and saucer eyes. Old dictionaries state that there is a phrase 'to take boggard' which means to take fright. Hob Hill near Graves Park was a place believed to be frequented by hobgoblins.

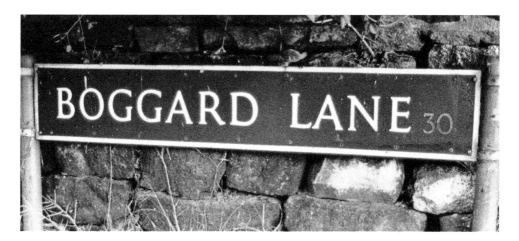

Boggard Lane.

River Crossings

The most important river crossing in Sheffield is Lady's Bridge over the River Don, marking the entry into the early town from the north. The stone-built Lady's Bridge was constructed in 1486 to replace an earlier timber structure. This late medieval bridge, which is hidden below the modern bridge, has stood the tests of time and attests to the excellent craftsmanship of its builder, master mason William Hyll, and to the critical eye of local citizens. Hyll's instructions in his agreement to build the structure were that he should 'make a sufficient brygge over the water of Dune neghe the Castell of Sheffield, welle and sufficiently after the sight of workmen of the same crafte and gode men of the parysh'. Lady's Bridge is so named after the Chapel of Our Blessed Lady of the Bridge, which stood to the south of the river beneath the castle walls. This chantry chapel was where travellers could pray for a safe journey. It became disused after the Reformation and had become a wool warehouse by 1572, and then an almshouse for poor people.

Lady's Bridge.

The Leppings.

Much less grand than Lady's Bridge, was another river crossing further upstream on the Don between Owlerton and Wadsley Bridge which survived until about a century ago. Moreover, this was only for travellers on foot because it involved crossing the river by leaping from one stepping stone to the next. Significantly, it was called 'Leppings', commemorated now in the street name Leppings Lane and as a part of the Sheffield Wednesday football ground.

Snig Hill

An important route in the medieval town, extending from the bottom end of the old Market Place, was Snig Hill. The probable meaning of the word 'snig' is a block of wood

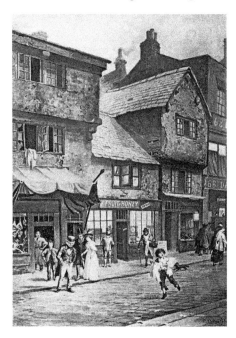

Old houses in Snig Hill from a watercolour by Arthur Wilson, 1800s.

that was put through and under cartwheels to act as a brake. In addition, as Snig Hill led to the manorial corn mill at Millsands, many a heavy load must have needed to be braked on this steep hill. At the bottom of Snig Hill is an area known as West Bar, probably denoting an entry point into the early town.

Spital Hill

Spital Hill is so-called because it was the site of a hospital founded by William de Lovetot, the Norman lord of the manor. The hospital was dedicated to St Leonard. It was deliberately sited outside the early town because it would have been, in part, an isolation hospital and therefore needed to be located away from the town's population.

The Wicker

The Wicker, stretching north-eastwards from Lady's Bridge to its junction with Spital Hill and Savile Street is one of the few streets in central Sheffield that is almost completely flat. This is not surprising as it is close to the River Don on its flat flood plain, which probably accounts for its name. Wicker is either from the Old Norse word 'vikir' or the Middle English 'wicker' which both mean 'willow', this tree being typical of low-lying marshy areas or from the Old English 'wic', an outlying farm, together with the Old Norse 'kjarr' which means marsh, together meaning an outlying farm in the marsh. On the Wicker were the town's archery butts and, until it was moved to Barker's Pool, a cucking stool (see below).

The route of the Wicker in the past went through an open area called Sembly Green. Sembly is just an abbreviated form of 'assembly' because here in the late medieval and early modern period the lord of the manor, or his representative, inspected the town militia. In 1637, for example, 140 men with 'Horse & Harnesse' were assembled for 'Confirmeing of the Peace of Our Sovereigne Lord the King'.

Barker's Pool

This large open space, which today has on its edges Sheffield's John Lewis department store and the City Hall, has a most interesting history. In the medieval period, beyond the end of Fargate lay Balm Green which contained Barker's Pool, a source of fresh water for the town's residents to supplement the supply from public and private wells. Details of major improvements survive from 1572 when it was re-walled, 'feyed', i.e. cleaned and a bolt and lock fitted to the shuttle. The shuttle or sluice gate was an important feature as water from the pool was occasionally released and channeled through the town to clean its streets, eventually finding its way into the River Don down Water Lane and Truelove's Gutter. Barker's Pool also at one period contained the town's 'cucking stool' for ducking objectionable persons who spread malicious gossip! A cucking stool was rather like a seesaw but with a seat at only one end. The victim would be locked in the seat, and then raised into full public view. The whole contraption would then be swivelled round over the water and operators would then duck the culprit a number of times no doubt accompanied by shouts and jeers from a baying crowd.

The Moor

It was always amusing in the 1970s to walk down The Moor, one of the busy shopping streets in the city centre and pass at the bottom a public house called The Moor. The inn sign showed sheep and a sheep dog on high moorland. However, the word 'moor' does not only mean heather-clad moorland, but low-lying, often marshy, common land for the use of the people of the town. This is its meaning in the case of the Moor in central Sheffield, where the southern end was near the confluence of the Porter Brook and the River Sheaf. It was called Little Sheffield Moor and was the boundary of the medieval parishes of Sheffield and Ecclesall. After the common land was enclosed and the town spread southwards, the street was called South Street. It did not revert back to its old name until 1902. When these areas of common were enclosed in the late 1700s, one of the objections by local folk was the loss of peat turbary rights for their free fuel.

Paradise Square

Behind the cathedral lies the delightful Paradise Square, a throwback to Georgian Sheffield. Built on a sloping cornfield called Hick's Stile Field, it dates from a protracted period of building by the Broadbent family extending from 1736 until about 1790. It is composed of four rows of three-storey red-brick houses with fine doorcases, sash windows and parapets arranged around a central square. In what contemporaries described as a town of dark, narrow, smoky streets, it must indeed have looked and felt like living in paradise. Among its residents in the early nineteenth century was the sculptor, Sir Francis Chantrey.

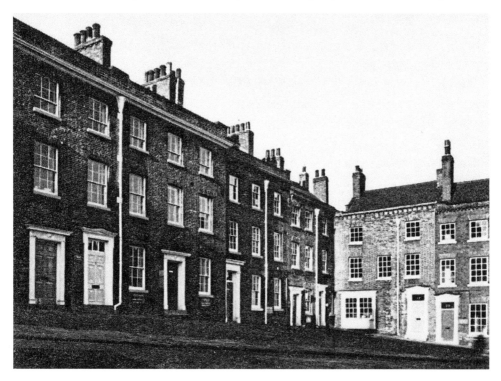

Paradise Square in the 1960s from Edward J. Vickers – old Sheffield Town.

Aristocratic Landowners

Not surprisingly, the two aristocratic families that owned large amounts of land in Sheffield have streets named after them. However, some are less obvious than others. For example, the dukes of Norfolk, the biggest landowning family, have left their names not only in street names but also in the names of public houses – at one point there were fourteen pubs with the name Norfolk Arms. There is a particular concentration of street names associated with the family in an area running eastwards and southwards from the edge of the medieval town down towards the River Sheaf, which was laid out in a gridiron pattern under the direction of the 10th Duke of Norfolk between 1771 and 1778. Norfolk Street and Norfolk Lane are self-evident; Howard Street bears the family name; Charles Street the Duke's first name, Earl Street, Arundel Street and Surrey Street are named after minor titles, and Eyre Street and Eyre Lane after the Duke's Sheffield agent. Fitzalan Square is also named after one of the dukes of Norfolk's family names.

Another aristocratic landowner, the 2nd Marquis of Rockingham of Wentworth Woodhouse acquired a large part of Ecclesall parish on his marriage to Mary Bright in 1752. When he died childless in 1782, his estates were inherited by his nephew, the 4th Earl Fitzwilliam. Hence, we have Rockingham Gate, Rockingham Lane, Rockingham Way, Rockingham Street, Fitzwilliam Gate and Fitzwilliam Street. Less obvious are five residential streets in Ecclesall: Harley Road, Haugh Lane, Hoober Avenue, Hoober Road and Cortworth Road, all named after localities near Wentworth Woodhouse on the Fitzwilliam estate.

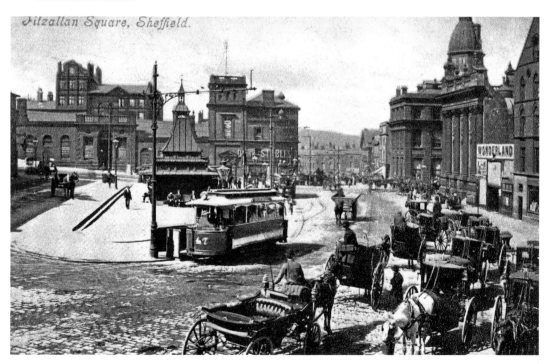

Fitzalan Square.

Hunter's Bar.

Hunter's Bar

The Hunter part of the name comes from the Hunters, a local farming family who had a farm here for around 200 years. The Bar part of the name comes from the fact that a toll bar was erected here in 1811 on the new Ecclesall Road leading towards the Peak District. The toll bar was the last one in Sheffield and only ceased to operate on 31 October 1884 to much celebration. Toll bar stoops were re-erected on the traffic island at Hunter's Bar in 1957 to mark the spot where the toll bar and the toll house stood.

Places in a Nook

There are at least three places in Sheffield whose name ends in 'all' from the Old English 'halh' meaning a nook of land. One of these is Ecclesall, which is located in the very corner of the old West Riding of Yorkshire next to the boundary with Derbyshire and the old boundary between the Anglo-Saxon kingdoms of Northumbria and Mercia. The others are Darnall and Worrall. Darnall means a secluded nook and Worrall means the nook where myrtle abounds.

Did You Know That?

The names Ecclesall and Ecclesfield incorporate the Celtic word 'egles', meaning church? The use by the Saxons in their name-giving of the Celtic word suggests that there was a church in the original large parish of Ecclesfield when the heathen Saxons arrived. Ecclesfield means the unwooded area in an otherwise well-wooded landscape containing a church. Ecclesall was in a nook (halh) of land as already noted.

Crabtree

Now part of the northern suburbs of Sheffield, the name of this area has a very unusual origin. The name appears to have originated at a relatively late date if the indenture of a lease dated 1 August 1614 is taken at face value. On that date, a lease was agreed and signed between the 7th Earl of Shrewsbury and his tenant, William Slater for a 20-acre farm called Wilfield Gate in Northwood (now Norwood). Today Norwood Road goes right through the centre of the area. The lease was for twenty-one years. As part of the lease, the tenant was instructed to repair the hedges and fences 'with quick sette and quick proof', i.e. with hawthorn. Every year he had to 'plante and sette four oake plantes or ash plantes in the said hedges and fences' and 'four crabtree stockes and graft them or cause them to be grafted with some good fruite'. Altogether, over the twenty-one-year period of the lease, this would have amounted to eighty-four oaks or ashes and eighty-four crab apple trees. They must have done so well that the area was later called Crabtree.

Did You Know That?

Owlerton has nothing to do with owls? This may be a big disappointment to Sheffield Wednesday fans. Because the Hillsborough ground is in Owlerton the fans have carried an owl on the club crest and their match mascot is also an owl. Owler is in fact a local dialect word for an alder tree so that Owlerton means 'farmstead by the alders'.

3. Monuments and Memorials in the Landscape

Monuments cover the landscape – if you know where to look! Some can be seen from considerable distances; others you have to get close up to. They usually commemorate the lives of individuals or groups of people, some of them large groups.

The Birley Stone

Lying at 816 feet (249 metres) at a wonderful vantage point above the Don Valley, at the top of Jawbone Hill between Grenoside and Oughtibridge, the Birley Stone marks an important medieval boundary. It was first recorded – as Burleistan – in a boundary agreement in 1161 between Richard de Louvetot, lord of the manor of Hallamshire, and the monks of the abbey of St Wandrille in Normandy. This abbey had been granted land in the ancient parish of Ecclesfield and by 1273 monks from the abbey had founded Ecclesfield Priory. In the boundary agreement, the monks were to have the freedom to pasture their flocks of sheep and cattle from January to August in a great wood that covered the valley side as far as the Doun (the River Don) from Wereldsend (Wardsend) to Uhtinabrigg (Oughtibridge). The monks were also permitted to pasture their swine on the fallen acorns in the same wood in the autumn. The remnants of this great wood remain as Wilson Spring Wood and Beeley Wood. The base of the stone may be the original medieval one but the shaft is later. Indeed the original stone may not have been a straight stone shaft, but a stone cross to mark the way from Ecclesfield to Bradfield via Oughtibridge and Worrall.

Beside the Birley Stone stands the Festival Stone, so-called because it was erected by Wortley Rural District Council to celebrate the Festival of Britain in 1951. This is topped by what has variously been called a 'topograph' or a 'toposcope', which is a display showing the direction and distance from the stone of natural and built landmarks.

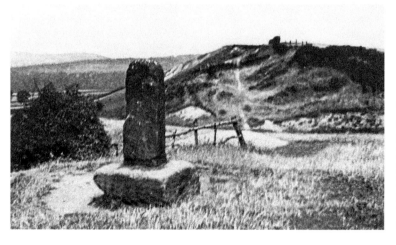

The Birley Stone – a boundary mark or meer-stone on Birley Edge and referred to in a Lovetot charter of 1161, from T. Walter Hall, 1934.

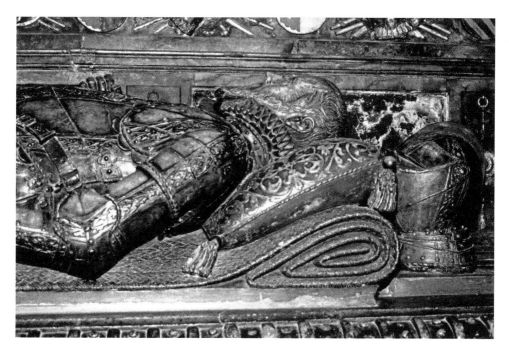

The 6th Earl of Shrewsbury's tomb in Sheffield Cathedral.

Lords of the Manor

The most sumptuous monument to the old lords of the manor must be the tombs of the 4th Earl of Shrewsbury (1468–1538) and his two wives, and the 6th Earl of Shrewsbury (1528–90) in Sheffield Cathedral. The effigy of the 6th Earl has him lying on his tomb with his head on a pillow and his feet resting on a dog. The dog is a Talbot, now an extinct breed. Talbot was the earl's family name, though it was a broadly generic term for a type of hunting dog.

The Cholera Monument

This monument is on the hillside above the main railway station and can now easily be seen from the top of Howard Street. It was erected in 1834 to commemorate the 402 people of Sheffield who died in the cholera epidemic of 1832, including the master cutler, Mr John Blake. This epidemic began in the Ganges Valley in India in 1826 and gradually spread westwards through Afghanistan into Persia and southern Russia. By 1831, it had reached Germany and then it is thought to have entered Britain at Sunderland on 19 October 1831. By the time the disease had run its course, 22,000 people had died in England alone. The first confirmed case in Sheffield appeared on 8 July 1832 and the disease ravaged the town throughout July, August and September. Burials in public graveyards were forbidden after 8 August and from then on they took place in a special burial ground in Norfolk Road. It was here that the cholera monument was erected. However, things were so improved by November that on 22 November a 'Day of Thanksgiving' was held. The outbreak and the death toll reflect the appalling conditions of poor sanitation and very limited medical provision ant the time.

The cholera monument.

Monuments on the Move

At least three monuments have been moved since they were first erected. Of these, one was to James Montgomery, one to the fallen in the Crimean War, and one to Queen Victoria.

James Montgomery, local newspaper editor, prolific hymn writer and campaigner against slavery and the employment of children as chimney sweeps died in 1854. His funeral was one of the finest that Sheffield has ever known. One hundred and sixty carriages led the procession ahead of the hearse from his home at The Mount in Broomhill to the General Cemetery and crowds six deep lined the route. John Newton Mappin, one of Sheffield's leading industrialists, paid for a statue to be raised in Montgomery's memory. This stood in Sheffield General Cemetery until its removal on the bicentenary of his birth in 1971 to a new site outside Sheffield Cathedral. The Montgomery Hall was also named in his memory.

The Crimean War Memorial commemorates the lives of the soldiers and sailors killed in the Crimean War of 1854–56 and was paid for by public subscription. Florence Nightingale, brought up in part at nearby Lea Hurst in North Derbyshire, was one of the subscribers. It was placed near the centre of the then town at Moorhead and stood there for more than a century before being moved to the Botanical Gardens in 1960. On the original memorial, the statue of Victory was seated on a tall pillar but this was not used when the monument was re-erected in the Botanical Gardens. Now Victory sits on a large base stone.

The Queen Victoria Monolith was erected to celebrate the Queen's Golden Jubilee in 1887 and stood in Town Hall Square at the junction of Leopold Street, Fargate, Surrey Street and Pinstone Street. In 1905, it was re-erected in Endcliffe Park and replaced by a statue of Queen Victoria herself, which in turn was also taken down and re-erected in Endcliffe Park. On the base stone of the Queen Victoria statue, various figures are carved

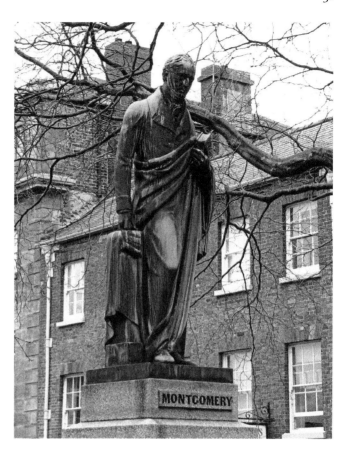

Statue to James Montgomery beside Sheffield Cathedral.

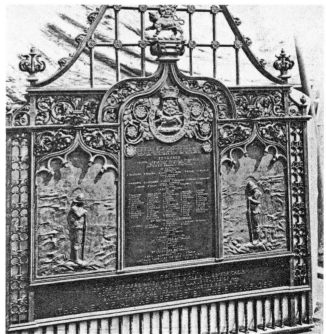

The South Africa War Memorial, formerly outside Sheffield parish church (now the cathedral) and pictured in 1905.

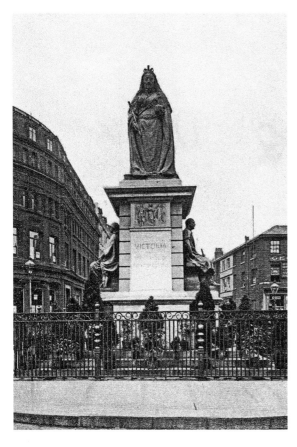

Left: The Queen Victoria Memorial, Sheffield, at the top of Fargate, 1905.

Below: The Royal Arch on West Street, probably 1920s.

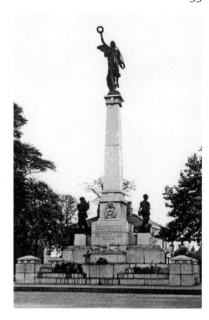

The War Memorial, Weston Park, 1920s.

including a muscular male representing Labour and on another a woman breastfeeding representing Maternity. Local historian J. Edward Vickers, writing in 1986, reported that some people have said that the breastfeeding woman ought to represent Conservative so that both major political parties are depicted!

Monuments to Sheffield's Famous Victorians

Not surprisingly, Sheffield's famous Victorian residents are widely commemorated in the landscape. Some have a simple monument, like that to James Montgomery or Ebenezer Elliott. Others have larger imposing monuments like the 28-foot tall granite obelisk to Sir Francis Chantrey in Norton village.

Many of Sheffield's most notable Victorians are buried in the General Cemetery that occupies a valley-side location in the Porter Valley between Sharrow Head and Ecclesall Road. This was opened in 1836 and the last burial took place in 1978. Altogether 87,000 burials took place there. Among the famous Sheffield residents buried there are: George Bassett (1818–86) the confectioner whose company invented Liquorice Allsorts; John Thomas Cole and Skelton Cole, the two brothers who founded Cole Brothers department store in 1847 (now John Lewis'); Mark Firth (1819–1880) industrialist and benefactor, Samuel Holberry (1816–1842) a leading figure of the Chartist movement, and William Prest (d. 1885) who co-founded Sheffield Football Club (the first in the world).

In some cases there may be a stained-glass window in a church, as in the case of children's writers Margaret Gatty and her daughter Juliana Ewing, both in St Mary's at Ecclesfield. In other cases, these famous Victorians are not merely commemorated by a stone monument or window; for important benefactors their name may be attached to a building such as the Mappin Art Gallery or the Graves Art Gallery or a public park as in the case of Firth Park or Graves Park.

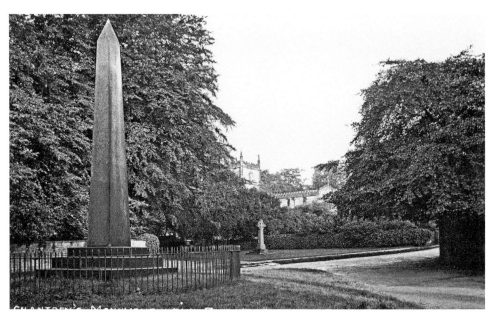

Above: Chantrey Monument, Norton, probably 1940s.

Left: Memorial window to Juliana Ewing in St Mary's church, Ecclesfield.

National Naval Hero

Buried in the same grave as Margaret Gatty in St Mary's churchyard, Ecclesfield is her father, Alexander John Scott. Many local people are totally unaware that he was one of Admiral Lord Nelson's closest associates and aboard HMS *Victory* at Trafalgar. He was Nelson's chaplain and intelligence agent and when Nelson was fatally wounded, Scott nursed him for three hours until he died in Scott's arms. The chaplain then kept a vigil over his body. Later Scott seldom spoke about the battle, and when he did, described it succinctly as like 'a butcher's shambles'. Scott himself died in Ecclesfield in 1840 while visiting his daughter.

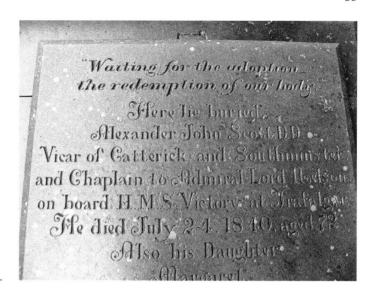

Grave of Alexander John Scott, Nelson's chaplain, in Ecclesfield churchyard.

Parkin Jeffcock

Another hero, much more local, was the mining engineer Parkin Jeffcock. Born at Cowley Manor, Chapeltown, he is also buried in the churchyard at Ecclesfield. He was in partnership with J. T. Woodhouse of Derby, and Oaks Colliery at Barnsley was in their care. On 12 December 1866, he was called to the Oaks Colliery where an explosion had taken place. Three hundred and forty men and boys were down the pit when the explosion occurred. By the time Jeffcock arrived at the colliery, eighty men had been brought out of the pit of whom nineteen were still alive. At 7 o'clock the next morning Jeffcock and twenty-six other volunteers descended the shaft to look for survivors. Two hours later, there was a second explosion and then a third. Jeffcock and the other volunteers were all killed and only six survived of the original 340 men and boys down the pit when the first explosion occurred. St Saviour's church at Mortomley was built by his family in Parkin Jeffcock's memory.

St Saviour's church, Mortomley, built in memory of Parkin Jeffcock, mining engineer.

Monument to the Trickett Family

One of the most moving monuments in the Sheffield area lies in the churchyard at High Bradfield. It records the death of all the members of the Trickett family in the Great Sheffield Flood of 1864. Just before midnight on 11 March 1864, the peaceful Loxley Valley was the scene of one of Britain's major disasters. The Dale Dike Reservoir collapsed and the waters burst down the valley towards Sheffield 8 miles away. The crushing torrent of water swept everything before it – cottages, farm buildings, water-powered mills, bridges, farm livestock, and people. The waters swept on, unstoppable into central Sheffield. Two hundred and forty people drowned, 415 houses and 106 works and shops were completely or partially destroyed, 693 farm animals were lost, and fifteen stone bridges were swept away. The gravestone to the Trickett family has this simple message:

James Trickett aged 39 years
also Elizabeth his wife aged 36 years
also Jemima their daughter aged 12 years
also James their son aged 10 years
also George their son aged 6 years
who perished in the Great Flood at Malin Bridge
caused by the bursting of the Bradfield Reservoir
March 12 1864

Who'er may be blamed for the recent distress
Our duty to God it makes none the less
Whate'er be the fault this is most true
The Flood is a warning to me and to you

Two Living Tree Monuments and One Dead One

In South Yorkshire, fig trees growing along the River Don in the east end of Sheffield constitute the biggest population of wild figs anywhere in Britain. In a survey carried out in the 1980s, fig trees were found well established on the banks of the River Don from the middle of Attercliffe to beyond the Tinsley viaduct at Meadowhall that carries the M1 motorway. In that survey, thirty-five mature trees were mapped. At one location, they formed a small wood rooted in the base of retaining walls, on a small island, and on earth banks. The trees were thought to be around 60–70 years old. No young fig trees were found during that survey though they have been discovered since. It is believed the seeds from which the fig trees grew originated in raw sewage deposited in the river during storms when the sewers overflowed. It is suggested that they germinated because of the warm microclimate that developed because of the hot water discharged into the river from neighbouring steel works. Since the decline of the steel industry the river temperatures have normalised, the microclimate has disappeared and few young trees have germinated. Nevertheless, the mature trees hung on as they do to this day. Working with one of the authors the late Oliver Gilbert, urban ecologist, considered the River Don figs as much a part of Sheffield's industrial heritage as a Bessemer converter, a steam hammer, or crucible steel! They are living monuments to a rich industrial past and were designated a locally protected species in the Sheffield Nature Conservation Strategy

of 1991, perhaps the only alien species so designated in Britain. Visitors still travel from as far away as the USA to view the Sheffield fig forest made famous by Dr Gilbert. However, a little-known fact is that they were actually discovered in the 1970s by industrialist Richard Doncaster and he alerted local botanist Margaret Shaw. Margaret organised the first River Don botanical surveys and it was this that triggered Oliver's interest.

Another living monument is located on private property in Bents Green. This is at Thryft House where there stands an ancient yew tree with a girth of more than 15 feet (4.56 metres). The tree occupies a right angle in a boundary wall at a habitation that is in itself of great antiquity, Thryft House being mentioned in a deed of 1504. It is what is known as a veteran tree and could be between 1,000 and 2,000 years old. Whatever its age, the Thryft House yew is probably the oldest living thing in Sheffield. It is in fact an old boundary marker marking the border between John Bright's Ecclesall estate and the surrounding lands of the lords of Hallamshire. We know from a surviving record of a perambulation of the Ecclesall estate in 1574 that yew trees were used as boundary markers.

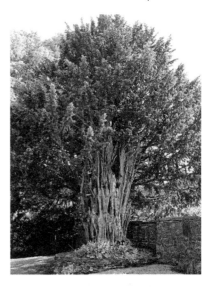

Ancient yew at Thryft House, Bents Green.

Wild figs on the River Don.

38

Did You Know That?

In the Botanical Gardens, there is the base of the trunk and roots of a fossilised 'tree' discovered during mining operations estimated to be 250 million years old! Discovered in the site of the Chapeltown railway station, it was formerly in High Hazels Park in east Sheffield but was moved to the Botanical Gardens so that it could be better protected. Of course, it was not really a 'tree' as such, but a giant clubmoss, a cousin of the modern-day ferns.

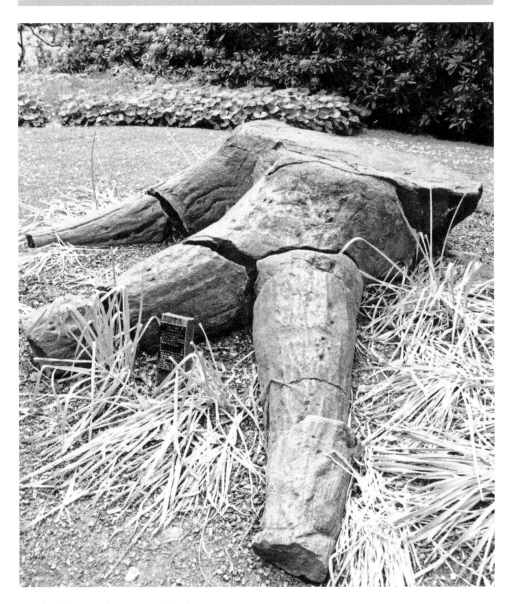

Fossilized tree in the Botanical Gardens.

4. Industrial Development

Sheffield's setting amid abundant natural resources of woodland, water and the underlying geology of coal, ironstone and other ores and quarry-stone has driven and shaped its industrial development for over 1,000 years. Woodland provided materials such as for buildings, charcoal, white-coal, and tan-bark. With a network of five rivers and many streams flowing through steep valleys, water was harnessed via water-wheels to provide power for forges, grinding wheels and various other industries. Ironstone and other ores were close to the surface and could be easily worked. This combination of natural resources led to the rise of the metalworking industries, which have made the Sheffield name world famous as the Steel City. At the same time, ancillary trades developed around metalworking and others developed from advances in associated technologies. Today, much of this has disappeared or changed beyond recognition. This chapter looks at some of the less well known of the industries and companies that are part of Sheffield's industrial legacy.

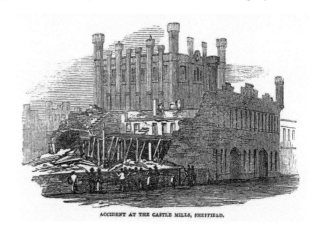

The 1854 explosion of a test boiler and disaster at Castle Mills, near Lady's Bridge on the River Don.

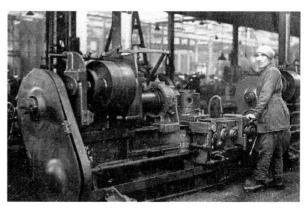

Female munitions worker in the First World War.

The Tanning Industry

The leather tanning industry was once an important part of the local economy in the Sheffield area. Between the sixteenth and eighteenth centuries, it was second only to the cutlery trade. Leather was used for a range of products, for example, boots and shoes, horse saddles, harnesses and collars but the Sheffield tanners specialised in heavy leather used in the local metalworking industries for smiths' aprons, bellows, belts for the water-powered grinding hulls etc. The industry was so large in the early seventeenth century that Sheffield tanners bought cattle hides from London. These were transported by boat inland as far as Bawtry and then by wagon to Sheffield. In the eighteenth century, tanners in the Sheffield area petitioned Parliament to regulate the iron trade from the American colonies because they were frightened that the influx of iron would lead to the local iron trade declining and with it the demand for charcoal and oak trees. Because of this, the supply of oak bark for tanning would suffer and with it their businesses. The tanning industry was a dirty, smelly one but highly specialised, and like many trades, handed down from father to son. The large-scale tanyards nearest to the centre of Sheffield were on Green Lane owned by Thomas Aldham of Upperthorpe. Further afield but now part of Sheffield were Rawson's tanyards, at Owlerton then in Ecclesfield parish and the tanyards at Woodhouse. Rawson's Dam still exists but is now a fishing pond. The industry had declined by the end of the nineteenth century as demand for its products decreased. The noxious nature of the tanyards, coupled with the rise in public health regulations, also meant that it was no longer acceptable or practicable to have them polluting the watercourses close to large populations.

Charcoal and Other Woodland Products

Local woodlands were worked and managed on an industrial scale into the early twentieth century. Not only did they supply timber for building materials, but also a range of other

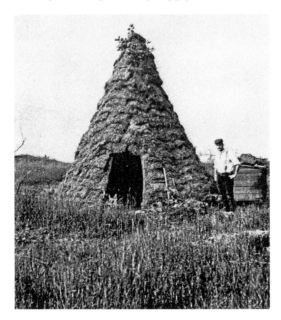

Charcoal burner's hut in Old Park Wood near Sheffield, from Addy 1898.

key products without which Sheffield's metalworking and other trades could not have existed. Charcoal was the main product from the local woodlands but white coal, tanbark and potash were also important in supporting local industry. Today it is still possible to see evidence of the industrial activity but it is difficult to imagine how different the woodlands would have appeared. Back then they would have been a hive of activity with whole families of itinerant charcoal-makers and other trades living and working within the woods.

'Old Sheffield' Plate

In the 1740s, Thomas Boulsover started the development of the industrial method of fusing silver to copper to produce 'Old Sheffield' Plate. He was already working as a cutler but expanded his business to manufacture buttons from the plated metal. Metal buttons were fashionable at the time and made of plate were more affordable than those made from solid silver. Boulsover kept the process of producing plate secret for some years and made other small articles such as snuffboxes. His business partner at the time was Joseph Wilson who later went on to manufacture snuff at a mill off Ecclesall Road,the latter business surviving to this day. While Boulsover's name is probably quite well known, John Hancock, another cutler, further exploited and developed the use of 'Old Sheffield' Plate in the mid-eighteenth century. He manufactured larger objects such as candlesticks, tea urns and tankards targeted at the newly emerging middle classes who wanted silverware but were unable to afford solid silver pieces. In time however, 'Old Sheffield' Plate stopped being made as new techniques using electro-plating developed. This simplified the process and lent itself to greater mass-production.

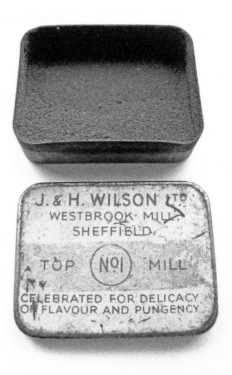

Wilson's Snuff, celebrated for delicacy of flavour and pungency.

Precious Metals – Refining and Smelting

Sheffield already had some cutlers specialising in precious metals (gold and silver) although there were more goldsmiths and silversmiths in London and the Birmingham area. On the back of the 'Old Sheffield' Plate industry John Read started the Sheffield refining and smelting trade. Read, the son of a Northampton farmer, was apprenticed to Skey's gold refinery and chemical works in Bewdley and on completing his apprenticeship was looking for a business opportunity. The burgeoning Plate industry in Sheffield provided this. The sweepings (dust), polishings and other waste from the manufacturing of Plate contained traces of silver and copper which when collected in large enough amounts and then smelted and refined yielded silver and copper in usable quantities. Read started his business in 1760 and its operation was at the forefront of technology for the time. His first small furnace was in Water Lane in the centre of Sheffield, but by 1770 he moved to larger premises in Green Lane where he also had his house. The business continued to expand as the precious metal trades grew and Read and his successors began to reclaim non-ferrous metals from local businesses. In the 1780s, Read leased Royd's Mill farm near the village of Attercliffe next to what is now the Washford Bridge over the River Don. At the time, there were only one or two properties between Lady's Bridge and Attercliffe. The farm buildings and surrounding fields became the headquarters of the Sheffield Smelting Company Ltd and there is still a metalworking business on the site. By 1860, the company had passed to the Wilson family who had married into the Read family, and they remained involved with the business until it was taken over in the 1970s. While the main refining and manufacturing site moved from Green Lane and developed at Royds Mill, the company also had a smaller factory on the corner of Arundel Street and Howard Street. This was in the centre of an area of little mesters' workshops and supplied them with silver sheet and cutlery blanks to produce some of the luxury silver items made in Sheffield as well as collecting the sweepings and waste for refining. The site of this factory is now marked by the water feature at the top of Howard Street, the mosaic representing the flow of molten metal from the furnaces. The company also had business premises in Birmingham's Jewellery Quarter and offices in London. In its heyday it had contracts supplying the Royal Mint, making gold and silver coin 'blanks' used to make the currency. It manufactured other non-ferrous products such as brazing rods and electrical contacts used in the early aircraft industry but its core business always included the processing and refining of the waste and sweepings from other businesses. Its fortunes began to decline as Sheffield's cutlery and luxury metal trades closed down or moved abroad. The Sheffield Smelting Company was taken over by American company, Englehards, in the 1970s. Despite being part of a global business, it closed in the 1990s as refining and smelting moved out of Sheffield and the UK.

Agricultural Implements

The production of sickles, scythes and other agricultural implements was another facet of the cutlery trade in Sheffield. The Staniforth family and their works at Hackenthorpe is one such example. The first set of major buildings for the Staniforth Works was built around 1736 but there had been Staniforths in the area working in the sickle and scythe

making trades from at least the seventeenth century. The company grew, first exploiting the water-powered sites in the Shire Brook Valley, to supply an ever-widening market in mostly agricultural implements for the overseas markets in the Americas, Australia and elsewhere. The following list is a small sample of the range made by Staniforth's of Hackenthorpe (taken from a 1930s catalogue held in Sheffield's Kelham Island Museum) and the countries to which they were sent:

America – American hay and manure forks
Canada
Australia – sheep shearers
South America – chilli sickles
South Africa – Cape bush knives
India – tea-bush pruners
Russia
Finland
West Indies – sugar sickles
New Zealand – fern hooks

The present range of buildings, on Main Street at Hackenthorpe, dates from 1820. By then the business had expanded and steam power was taking over from separate water-powered sites. By 1912, the Staniforth family no longer owned the works. However, the site was in operation until 1976 when it closed. In the late 1990s, the derelict site was bought and sympathetically restored as a series of small commercial units.

Huntsman and Crucible Steel

Benjamin Huntsman was a clockmaker in Doncaster, originally from Epworth in North Lincolnshire. In the 1730s, he moved to the Handsworth area of Sheffield, which was near to Catcliffe and its glassworks, when he was investigating producing finer quality steel for clock springs. He observed and used some of the techniques used at the Catcliffe glassworks to develop the 'crucible' method of making steel. His workshop and house,

Benjamin Huntsman's steel furnaces and offices, Attercliffe.

now demolished, were on Handsworth Road. A blue plaque on the 1930s house built on the site commemorates his stay at Handsworth. As the business developed, Huntsman moved to Attercliffe and developed the Britannia Works. The Crucible method of making steel continued into the twentieth century and formed the basis of the many large steel-producing companies along the Lower Don Valley around the Attercliffe area (see Chapter 5, Famous Victorian Residents), Huntsman was buried in the Top Chapel cemetery in Attercliffe.

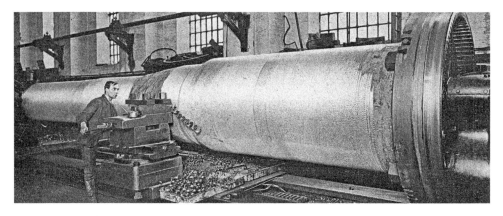

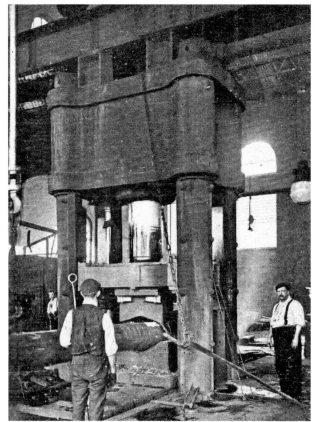

Above: Barrel for huge naval gun – turning a steel jacket at Vickers' works in 1905.

Left: Forging a gun-tube under a 6,000-ton press at Vickers' River Don Works in 1905.

Samuel Fox, Millionaire Industrialist

Samuel Fox chose wire drawing as his career and was apprenticed to Cocker Brothers who had a mill in Hathersage. He later went to work for them in Sheffield but left because he wanted to set up in business himself. Using capital from the sale of land left to him in his father's will, he first went into partnership at a water-powered mill in the Rivelin Valley but soon decided to go it alone and leased another water-powered site in the Little Don Valley just above Stock's Bridge, which was just that – a stone bridge across the river. There was no village and the area was completely rural. Nevertheless, his business went from strength to strength. To start with, Fox manufactured steel wire (for carding in the wool textile industry) and various kinds of pins. However, he had a keen eye for the market and began to make crinoline wire and umbrella frames. It is said that that sales of his Paragon umbrella frame brought him his first fortune of half a million pounds. In the late 1850s and early 1860s, he extended his Stocksbridge Works in order to be independent of his steel suppliers and to take advantage of the latest technology. In 1862, he installed two Bessemer converters, a cogging mill and a rolling mill. He had entered the bulk steel trade and steel rails for the railways brought him his second fortune.

Did You Know That?

By 1660 there were around fifty water-powered sites on Sheffield's rivers; this had risen to around ninety by 1740 and to around 130 by the end of the eighteenth century. At the height of the use of water power on Sheffield's rivers, they occurred on average four times on every mile of river.

Forge Dam in Porter Valley.

Do You Remember Izal?

It all started in 1885 with the appointment at Newton Chambers & Co. Ltd of an analytical chemist called Jason Hall Worrall, who began work on analysing the oil produced when coke was being made from coal at the company's coke ovens at Rockingham Colliery. The coke was the fuel for the company's blast furnaces at their Thorncliffe Ironworks between Sheffield and Barnsley, which had been established in 1793. Worrall eventually produced a germicidal oil which, when mixed with an emulsifying agent, disseminated through any liquid. In 1893, the company chairman announced to shareholders that the company had a trade secret that would one day be valuable. This was the non-poisonous disinfectant and antiseptic liquid developed by Worrall. It was called Thorncliffe Patent Disinfectant before being given the name Izal. It is said that Izal is an anagram of Liza, Worrall's favourite sister, but there is no direct evidence to support this belief.

The disinfectant soon attracted favourable reports from eminent bacteriologists, including the claims that it would kill the germs of diphtheria, typhoid fever, fowl cholera, swine fever, worms and malaria and even cure perspiring feet and baldness! The loved (or hated) Izal toilet paper was initially given away to customers (usually public authorities and hospitals) who bought large quantities of the disinfectant and was not sold to the public until 1922 when it was impregnated with Izal. The toilet paper was used to advertise other Izal products, of which eventually there were 137 including San Izal disinfectant, Zal Pine disinfectant, various soaps, shampoos (including veterinary shampoos for pets), shaving foams, Polly kitchen rolls, and even Izal lozenges and mints. In 1924, W. Heath Robinson was invited to Thorncliffe and he produced many amusing illustrations that were used on the toilet paper and on a series of postcards. During the 1930s amended nursery rhymes were also printed on the toilet rolls, for example:

Jack and Jill climbed up the hill
Today we'd call it hiking,
An Izal bath as an aftermath
Was greatly to their liking.

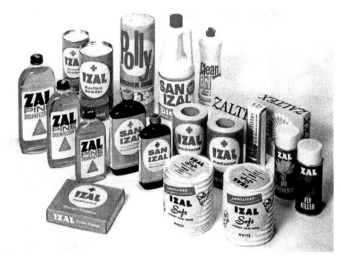

Izal products.

Newton Chambers were taken over by Central & Sheerwood in 1973 and the Izal division was sold to Sterling Winthrop. The Lever Group acquired Izal to sell to industrial customers while Jeyes, still carrying the Izal trademark, supplied the retail sector.

Smithy Wood Coking Plant

Often cloaked in smoke and steam, Smithy Wood Coking Plant, between Ecclesfield and Chapeltown, was a vital part of the Newton Chambers enterprise. Here from 1929, coal was converted into coke for the blast furnaces, and as a by-product, oil was extracted for the production of Izal, the disinfectant. The plant consisted of fifty-nine coke ovens of the most modern type when installed by Woodall-Duckham. Newton Chambers supplied all the constructional ironwork for the erection of the plant.

The plant was designed to produce coke oven gas for Sheffield Gas Company, together with 5,800 tons of coke, 100 tons of ammonium sulphate, 68,000 gallons of tar and 29,600 gallons of crude benzole every week. Its operation was continuous and an oven was discharged and recharged every twenty minutes. It was linked to collieries and the ironworks by an overhead ropeway system. It was nationalised at the end of 1946 and closed in the mid-1980s. The plant was demolished in 1987 and the site today, looking remarkably green, is occupied by the newly completed Smithy Wood Office & Business Park.

Hall & Pickles Hydra Steel Works

Hall & Pickles were a firm of metal merchants and iron stockholders established in Manchester in 1812. In 1914, they opened branch premises in central Sheffield to produce crucible steel and then moved to another site on Bessemer Road at Attercliffe. In 1931, they bought what was then a greenfield site on Nether Lane in Ecclesfield and built their Hydra Steel Works. At the Hydra Works, they installed an electric high-frequency induction furnace, a forge, a wire mill, a machine shop, laboratories and offices. All their Sheffield business transferred to the Ecclesfield site after the Bessemer Road site was bombed during the Second World War. Among their products were heat-resisting and stainless steels, electrical resistance wire and high-quality engineers' cutting tools. Many people will remember their trademark – a line drawing of a striding man rolling up his sleeves, known as the 'go to it' Hydra Man. The Hall & Pickles Works has now gone from Ecclesfield and the site is the Hydra Business Park.

Did You Know That?

Harry Brearley, the discoverer of stainless steel, which almost completely resisted corrosion, came from a poor background having been born in Ramsden's Yard off the Wicker. He later claimed that on leaving school he had been taken on as a bottle washer by the chemist in the laboratory at Firth's steelworks because his face was cleaner than another's!

Sheffield Coal Company

Formed in 1830 via a series of mergers, the Sheffield Coal Company (SCC) rapidly became a major employer with the development of its deep coalmines. Two of its directors were William Jeffcock and Thomas Dunn, the first and second mayors of Sheffield respectively. SCC opened coalmines to the south-east of Sheffield. One of the first was at Birley West in 1855, eventually producing nearly 2,000 tons of coal per day. A large proportion of the output was converted to coke as the company was quick to exploit an outlet for their products in nearby Sheffield. Coke was necessary for the production of crucible steel. The company wasted little of value, briquettes were manufactured at Birley West from washed slack and tar, and the site housed a clay pit, brickyard and chemical works. Both above and below ground the colliery was well lit with one of the earliest examples of electric lighting on a major scale in the country. On the surface, the railway was illuminated at night by twelve large sun-lamps as were the pit bank and screens. Below ground, all the main roadways were lit for at least 200 yards from the bottom of the pit shaft. Birley West closed in the early twentieth century but by then SCC had opened at the larger Birley East mine. United Steels purchased SCC in 1937, expanding their coal mining in the local area as it already included the nearby Treeton and Orgreave Collieries among its assets.

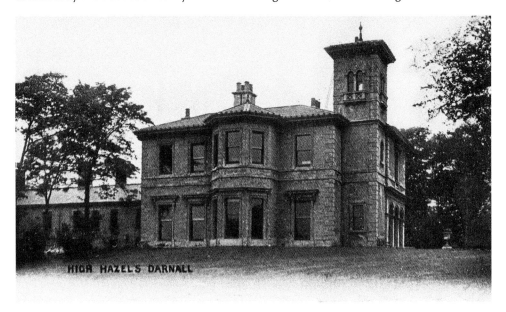

HIGH HAZELS DARNALL

High Hazels House, home of William Jeffcock, first mayor of Sheffield.

Did You Know That?

The topping of stone walls all around the Sheffield area, which looks like large, crude, black lumps of Aero chocolate, is in fact furnace slag mostly from cementation furnaces. It has its own dialect name – crozzle. Moreover, well-cooked crispy bacon is still known as 'crozzled' bacon in the Sheffield area.

'Crozzle' on a Sheffield wall.

5. Famous Victorian Residents

Advert for Arthur Davy & Sons food providers, 1896.

Over the centuries, a galaxy of men and women, both Sheffield-born and long-term residents, rose to local, national or international prominence in their chosen field. This is particularly true of the Victorian period when Sheffield was booming economically and expanding rapidly. Some of these famous residents also left their mark because they were important benefactors. Successful industrialists loom large in this selective list, but the eminent Victorian residents whose lives are discussed here also include scientists, engineers, musicians, poets, historians and writers.

Captains of Industry

John Rodgers (1779–1859) followed his father and grandfather, both Joseph Rodgers, to be head of the firm of Joseph Rodgers & Sons, the leading cutlery firm in Sheffield and – for much of the nineteenth century – in the world, with its famous double mark of a star and Maltese cross, which was granted by the Company of Cutlers in 1764. In 1821, John Rodgers was introduced to the Prince Regent and presented him with a tiny knife containing fifty-seven blades. In return, the Prince Regent presented the firm with a Royal Warrant.

Closely following on the heels of Joseph Rodgers and Sons as the major Sheffield cutlery firm in the nineteenth century was the firm of George Wostenholm & Son, very ably led by George Wostenholm (1800–76). After serving an apprenticeship with his father (who died in 1833), he was brought into the firm which was then named George

Wostenholme & Son (the final 'e' was said to have been subsequently omitted to get the full name on knives). In 1826, George Wostenholm became a freeman of the Company of Cutlers and was granted what was to become his famous trademark I*XL (I excel). He produced high quality products largely aimed at the American market – razors and a wide range of pocket knives – working knives for farm and frontier with acid etchings pandering to the American taste and with ivory and pearl handles, and of course Bowie knives in very large numbers.

Equally swift in their rise to business success and large fortunes were members of the Mappin family, John Newton Mappin (d. 1884) and Sir Frederick Thorpe Mappin (1821–1910). John Newton Mappin was a successful brewer who left money in his will for the building of the Mappin Art Gallery and who bequeathed more than 150 pictures to the gallery. His nephew was Frederick Thorpe Mappin who succeeded his father in 1841 as head of a firm, which manufactured a variety of knives and razors. He had joined his father at the early age of fourteen as partner and on his father's death he also took charge of his three younger brothers who were also introduced to the business, the firm renamed Mappin Brothers in 1851.

By the 1870s, another group of Sheffield steel manufacturers, this time in the heavy industry, had taken over from the cutlers and silver plate manufacturers as the leading businessmen and, in some cases, political figures in the town. This group was headed by Sir John Brown (1816–1896) who was the son of a slater born in a courtyard off Fargate in the centre of the town. He rejected his father's recommendation that he become a linen draper and started his working life as a cutler, then became a steel merchant and finally a steel manufacturer. In 1857, he moved from his works in the town to his new Atlas Works on Carlisle Street to manufacture railway components on a large scale – springs, tyres, axles, wheels and, most importantly, rails – and rolled wrought iron and steel plate for the Royal Navy's warships.

Not quite as important as a manufacturer as Sir John Brown, but as a benefactor with few equals was Mark Firth (1810–80). Mark was the son of Thomas Firth who had moved to Sheffield from Pontefract and became head melter for Sanderson's, crucible steel manufacturers. Mark's first job was as a clerk at Sanderson's but in 1846, his father together

George Wostenholm.

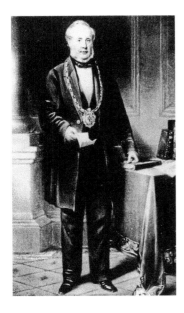

Sir John Brown.

with Mark and Mark's four brothers founded their own firm making crucible steel for axes, saws, files and later railway locomotive and carriage springs. Mark Firth became a wealthy man and eventually left his Wilkinson Street home for Ranmoor where he bought 26 acres of land in which he built a mansion, Oakbrook. Like John Brown, he rose to become master cutler (in 1867, 1868 and 1869) and mayor (in 1875). His gifts to the town were of immense value. He helped to fund the building of Methodist chapels, funded the building of almshouses at Hanging Water, founded Firth College, the forerunner of the University of Sheffield, and provided Firth Park for the town in 1875, carved out of his Page Hall estate.

Equally philanthropic were steel manufacturers Thomas Jessop (1804–1887) and William Edgar Allen (1838–1915). Thomas Jessop was born in Blast Lane, Sheffield Park, and joined his father, William, in their expanding steel firm of William Jessop & Son. Their main works was in Brightside and later another plant was opened at Kilnhurst, north of Rotherham. Thomas Jessop was elected mayor of Sheffield and master cutler in 1863. After the Sheffield Flood of 1864, he was responsible for raising the funds for the relief of the families affected by the disaster. He will be best remembered for providing nearly £30,000 for the building, furnishing and equipping of the Jessop Hospital for Women, opened in Gell Street in 1878.

William Edgar Allen was also born in Sheffield. He was an accomplished linguist who used his skills early on in his career as a foreign traveller for Ibbotson Brothers, cutlers of the Globe Works. He founded his own firm at the Imperial Steel Works in 1867. Allen gave substantial sums to a number of deserving causes but of particular note, he provided the Edgar Allen Library at the University of Sheffield and the Edgar Allen Institute for Medico-Mechanical Treatment on Gell Street.

Two other great Victorian Sheffield industrialists were Edward Vickers (1804–1897) and Charles Cammell (c. 1809–1879). Sheffield-born Edward Vickers took over the steel firm Naylor, Vickers & Co. from his brother and as expansion took place, moved the business

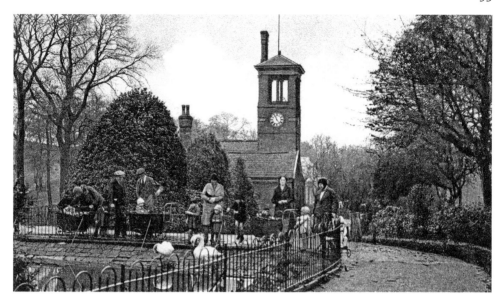

The duck pond at Firth Park in the early 1900s.

from the old Don Steel Works at Millsands in 1867 to the newly built Don Steel Works in Brightside. He was mayor of Sheffield in 1847 and a JP for many years. He lived for many years at Tapton Hall which he built in 1853, before retiring to Oxfordshire. His son, Thomas Edward Vickers (1833–1915) took over on his father's retirement, was elected master cutler in 1872 and later awarded the honour of the Companionship of the Order of Bath.

Charles Cammell was a native of Hull who, as a young man, arrived in Sheffield with just a few pounds in his pocket. Like William Edgar Allen, he worked for some years as a traveller for Ibbotson Brothers. He then co-founded a firm called Johnson, Cammell & Co. manufacturing edge tools and files. The business did well and became, as Charles Cammell & Co., a major manufacturer of steel components for the railways and later munitions, moving to the Cyclops Works in Savile Street as early as 1845, thus setting the trend for the industrialisation of the Lower Don Valley. In 1851, he bought Norton Hall and became 'squire' of Norton, dying there in 1879.

Scientists and Engineers

Sir Robert Abbott Hadfield (1858–1940), had the distinction not only of being a successful industrialist but also a brilliant applied scientist. Attercliffe-born, Hadfield was the son of Robert Hadfield who had moved from a career as a rate collector with the Board of Guardians into the steel industry and set up a business in 1872 that manufactured steel castings at the Hecla Works in Newhall Road. In 1883, at the age of only twenty-five, he took out his first patent for non-magnetic manganese steel. This was followed in 1884 with his discovery of silicon steel and various other alloy steels followed. On his father's death he became chairman of the firm and in 1898 opened a new site, the East Hecla Works, devoted almost entirely to the production of armaments. This location is now largely occupied by the Meadowhall Shopping Centre. He was master cutler in 1899, knighted by Edward VII in 1908, and elected a fellow of the Royal Society in 1909.

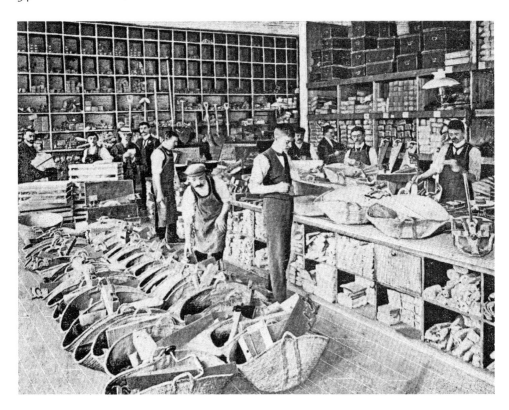

Examining tools before despatching at J. G. Graves Tool Factory around 1904.

Two of the country's great Victorian railway engineers, Joseph Locke and Sir John Fowler, were born in the Sheffield area, but Joseph Locke, went to live in Barnsley when he was five and really does not qualify for this list. Sir John Fowler (1817–98) was the child of John and Elizabeth Fowler of Wadsley Hall. John Snr was an estate valuer and surveyor. Young John Fowler was educated at John Rider's boarding school at Whitley Hall between Grenoside and Ecclesfield. He left school at sixteen and became a pupil engineer of Mr Towlerton Leather at Sheffield Waterworks where he received a good training in waterworks engineering and he became responsible for the superintendence of Rivelin and Crookes reservoirs. He helped to survey a possible route in the Upper Don Valley for a railway between Sheffield and Manchester. He also spent two years in London with the railway engineer J. W. Rastrick and then became resident engineer on the Stockton to Darlington Railway. He was an independent consultant railway engineer in 1844 when still only twenty-six years old and as such held the position of chief engineer of the Midland Railway. In the early 1860s, he was chief engineer on the construction of one of the earliest of London's underground railways, the Metropolitan Railway and later involved in the extension of the underground at deeper levels beneath the city. He was closely involved with the building of the Victoria and Pimlico railway bridges, the Sheffield–Grimsby railway, the London–Brighton line, and Millwall Docks as well as being involved in railway engineering schemes in Egypt, India and Norway. In 1866, he was elected President of the Institution of Mechanical Engineers. His greatest achievement,

Sir Robert Hadfield.

however, with his partner Sir Benjamin Baker, was the Forth Railway Bridge in Scotland, completed in 1890. The bridge is 1.5 miles long, 300 feet high, cost £3.5 million and at the time of its construction was described as one of the seven wonders of the modern world. In 2014, it became a World Heritage Site.

Dr Henry Clifton Sorby (1826–1908) came from a long standing Sheffield family that provided the first Master Cutler (Robert Sorby) in 1624. Sorby was of independent means and did not need to work for a living, but this modest and learned man dedicated his life to scientific research and, rather than become a member of one of the leading universities, he chose to live his life in Sheffield. His interests and achievements were far ranging. The Geological Society hailed him as 'The Father of Microscopic Petrology' (the microscopic study of the composition of rocks), and more importantly for Sheffield industry he pioneered the new science of metallography, the study of the microscopic structure and properties of metals. He was also an expert on meteorology, the composition of meteorites, the nature of colouring in hair, flowers, minerals and birds' eggs, the detection of poisons, aspects of Egyptology, and the materials used in Roman, Saxon and Norman architecture. He was a fellow of the Geological Society and of the prestigious Royal Society. He supported the University of Sheffield during its formative years and endowed a chair of Geology. The Sheffield-based Sorby Natural History Society, formerly, Scientific Society was named after him.

Charles Edward Dixon (1858–1926) was an English ornithologist, born in London but living in Meersbrook in Sheffield for around twenty years during the late 1800s. He was born in Camden Town, London in 1858, the son of landscape artist Charles Thomas Dixon and Louisa (née Edwards) Dixon, but moved to Heeley in Sheffield at a young age. By 1871, Dixon had become a pupil teacher (aged twelve) at Heeley School, but according to Harold Armitage, the author of *Chantrey Land*, the young Dixon was not interested in teaching and studying the required curriculum, but preferred to focus on natural history – particularly ornithology. In *Chantrey Land*, Armitage recalls finding Dixon perched on the

branches of trees or entangled in bushes, with his nose in a book. During the late 1800s, Dixon presented over 100 skins of birds to Sheffield Museums, but unlike many Victorian naturalists, realised the importance of field notes and observations. Many of the skins were 'swapsies' exchanged with ornithologists around the world and not local. Nevertheless, Dixon was fascinated by the commonplace, local, and gave specimens he collected from around Sheffield, particularly Heeley, Meersbrook and Norton Lees. Sad though this seems to us today, Dixon's collection gives a remarkable snapshot of the bird life of Sheffield at the time. He was a popular writer of the time and an avid field ornithologist who advocated watching birds through opera glasses rather than shooting them! Dixon discovered the St Kilda Wren and a new species in North Africa. He collaborated with Henry Seebohm, working with him on *British Birds,* and made important observations about bird evolution and behaviour. One of his main Sheffield books was *Among the Birds in Northern Shires*, published in 1900. In the preface to the American edition of Dixon's book *Rural Bird Life* Elliott Coues noted the originality of Dixon's field observations. Julian Huxley commented on the importance of Dixon's recognition of the value of prismatic binoculars for bird watching. In his later life, he contributed newspaper articles on a variety of themes such as horse shows, agricultural fairs, and other rural activities.

The Literary Elite

Sheffield's most influential writer – at least the most influential for those wanting to know about Sheffield and the surrounding area in the distant past – was not a novelist or poet but a historian. Revd Joseph Hunter (1783–1861) was born in Sheffield, the son of Michael Hunter, a cutler. His mother died when he was young and he was placed under the guardianship of and brought up by the Revd Joseph Evans, who was minister at the

The third Men's Hall – Sorby Hall, Sheffield University, 1970s.

Among the Birds in Northern Shires by Charles Dixon, published in 1908.

Upper Chapel in the town and of a Presbyterian church. Hunter received a rudimentary classical education at Mr Sorsby's school in Attercliffe and then in 1806 went to study at the Presbyterian College at York. In 1809, Hunter was made minister at Trim Street Chapel in Bath, remaining there until 1833 when he left Bath for London to take up an appointment as a sub-Commissioner of Public Records. In 1838, he became Assistant Keeper, First Class in the newly established Public Record Office. His output of published work was prodigious, covering a wide range of historical, archaeological and literary interests. He died in London.

Hunter's three major works on South Yorkshire were all published after he had left Sheffield. He was quoted as saying that his interest in antiquarian studies began when he was young and were 'among the amusements of childhood and the chief pleasures of youth'. He is known to have been an assiduous visitor on horseback to all corners of South Yorkshire in pursuit of his studies. His 'Church Notes' on South Yorkshire compiled in 1801–02 when he was only eighteen or nineteen, are in the British Museum. He took with him to Bath many of the assiduously collected raw materials for his later publications. He published his *Hallamshire* – full title *Hallamshire. The History and Topography of the Parish of Sheffield, in the County of York* – in 1819. This was followed by *South Yorkshire: The History and Topography of the Deanery of Doncaster* in two volumes in 1828 and 1831. In the short interval between these two volumes, he published (in 1829), *The Hallamshire Glossary*, a dictionary of the regional dialect of the Sheffield area. Alfred Gatty, who after Hunter's death revised, edited and republished Hunter's *Hallamshire*, was of the opinion that Hunter 'stands second to none amongst the names which do honour to Sheffield as a birth-place'.

Another local writer who lived a life quite different from Hunter's was the poet Ebenezer Elliott (1781–1849). Elliott was born in Masbrough, now part of Rotherham, but he lived in Sheffield for twenty-two years. He lived from 1819 to 1834 in Burgess Street off Barker's Pool and from 1834 to 1841 in Upperthorpe in the house built by Master Cutler John Blake who had died of cholera in 1832. After Elliott's death, the citizens of Sheffield and Rotherham subscribed £600 for the erection in 1854 of a bronze statue of him on a granite plinth. This stood in the Market Place before being moved in 1875 to Weston Park, where it remains. Elliott was one of eleven children born to Ebenezer Elliott Snr and his wife Ann. He was educated at a number of local schools, where he was thoroughly miserable and believed he had learned next to nothing. When he was sixteen, much to his relief, he was

sent to work in his father's iron foundry, in which he became a partner (probably on his marriage in 1806), and then took over the firm from his father and brother before going bankrupt in 1816. In 1819, with the help of a loan of £100 from his two sisters-in-law, he moved to Sheffield and set up a new business as an iron and steel merchant. By the 1830s, this venture had been enlarged to become a steel manufacturing firm.

As a young man, outside of work he attended chapel but later took to frequent visits to local public houses. He was said to have had no literary interests until he visited his aunt and happened to see a cousin's book on botany and then heard his brother reciting a poem about flowering plants. These ignited his interest in natural history and the world of books. He became a lover of nature and the local countryside and an avid reader of poetry, Gothic novels and books on topography and travel, which formed the basis of his early verse about seducers and cruelly deceived maidens.

This subject matter was dropped after 1815 with the passing of the Corn Laws, which were not repealed until 1846. To Elliott the Corn Laws not only interfered with free trade, they greatly increased the possibility of famine, and reduced the demand for manufactured goods at home and abroad, therefore increasing the possibility of widespread unemployment. His crusade was for working men and industrialists against the idle rich and parasites, referring to the latter as 'Lord Pauper' and 'Squire Leech'. He attacked the laws unremittingly for over a quarter of a century through lectures, poems, hymns and the press, and became a household name. Elliott was a small, mild-mannered man who was raised to a state of almost apoplectic wrath on the subject of this legislation. He did not believe in physical revolution (he resigned from the Chartist movement because they were embracing physical violence), but believed the world could be changed through education, hard work, the love of nature, dialogue between the classes, and of course, the repeal of the Corn Laws. His motto was one word: 'Right'. He often signed himself 'Ebenezer Elliott, C. L. R. [Corn Law Rhymer]'.

Elliott was more than a polemicist. His love of nature and local scenery inspired a series of poems in praise of the local landscape about such places as Rivelin, Roche Abbey, Win Hill, Wincobank Hill and the rivers Don and Rother. Even in his political verses his characters find time to, or are exalted to, commune with nature or wonder at the beauty of the local scene. Elliott left Sheffield for health reasons in 1841, going to live

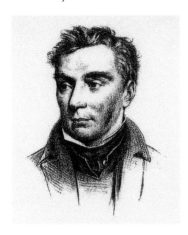

Ebenezer Elliott.

in retirement at Hargate Hill in Great Houghton overlooking the now famous mining town of Grimethorpe. He went for what was then a magnificent view and the healing air. He is buried in Darfield churchyard, and we wonder what he would have made of his view over Grimethorpe when deep coal mining arrived just a few decades after his death.

The countryside and natural history also provided a major stimulus for Mrs Margaret Gatty (1809–73) and her daughter Julianna (1841–85), better known under her married name of Mrs Ewing. Mrs Gatty was the wife of Dr Alfred Gatty (1813–1903), a Londoner, educated at Charterhouse, Eton and Oxford. He was received into holy orders in 1837 and then spent two years as curate of Bellerby in the parish of Spennithorne. While there, he met his future wife, who was the daughter of the Revd Alexander John Scott, Lord Nelson's former chaplain. Alfred and Margaret Gatty were married in 1839 and immediately moved to Ecclesfield where Alfred had been appointed vicar, a post that he occupied for nearly sixty-four years until his death in 1903 at the age of eighty-nine. Not only was he vicar of an enormous parish but he was a historian. His best-known works are his revised editions (1869 and 1875) of Hunter's *Hallamshire* and his popular history of Sheffield, *Sheffield Past and Present* (1873).

Margaret, his wife, wrote a number of best-selling children's books including three series of *Parables from Nature* (1855–71). These amounted to thirty-seven parables altogether, 'to gather moral lessons from some of the wonderful facts of God's creation', such things as the migratory urge of the sedge warbler, the purring of cats and the chirping of house crickets. One reviewer said of the first series that 'There is more poetry in this little book than in half the poems that come forth'. She was also the author of *Aunt Judy's Tales* (1859), based on goings-on in the nursery at Ecclesfield vicarage, 'Aunt Judy' being her second-eldest daughter, Juliana. Such was her fame that her publisher asked her in 1866 to edit a children's magazine, which she did until her death in 1873. Significantly, it was called *Aunt Judy's Magazine* and she attracted to it some very well-known authors. Translations of stories by Hans Christian Andersen regularly appeared, Lewis Carroll contributed a story, and most of her daughter Juliana's very popular stories appeared for the first time in the magazine. Famous Victorian illustrators also contributed including George Cruikshank, Helen Patterson, Randolph Caldecott and Gordon Browne. The magazine had worldwide not just British readership. Nevertheless, Mrs Gatty's interests went far beyond writing and editing publications for children. Margaret Gatty was a consummate naturalist and 1863 saw the publication of her magnificent and very influential *British Sea-weeds*, the culmination of fifteen years of obsessive collecting and classifying. The beautifully illustrated book was still in use at marine research stations around the British coast until well into the twentieth century. Mrs Gatty corresponded for years with the main authorities on the subject and had an Australian seaweed *Gattya pinella* and a marine worm *Gattia spectabilis* named after her!

Mrs Gatty was in her turn surpassed as a children's writer by her second daughter, Juliana. She wrote more than a hundred children's stories and published her first when she was only nineteen. Her output in the twenty-four year period from the publication of her first story in 1861 to her premature death in 1885 was prodigious: light verse, lyrics for songs, plays, short stories and full-length novels, all for children. Among her fairy stories *Lob Lie-by-the-Fire* and *The Brownies* are the best known – Baden-Powell taking the name 'Brownies' from the

latter for the junior branch of the Girl Guides. Although largely forgotten now, Juliana Ewing's books sold in their thousands and in her lifetime, she was compared to Lewis Carroll and Robert Louis Stevenson and was much admired by John Ruskin. Early in the last century, Rudyard Kipling and Arnold Bennett extolled her virtues as a writer.

Equally lost from the memories of most present-day Sheffielders is James Montgomery (1771–1854). He was a Scot and his father was pastor of the Moravian church in Irvine in Ayrshire. When he was six Montgomery was sent to the Moravian school at Fulneck near Leeds. While he was at school in Leeds, his parents went as missionaries to the West Indies and they died there. Meanwhile the school authorities apprenticed Montgomery – who was sixteen and already writing poetry – to a baker in Mirfield but he hated the job, ran away and turned up in Wath where he found employment in a general store. Before long, he left and went to London, worked for a publisher and bookseller, hoping to find a publisher for his poems. Failing miserably in this endeavour, after less than a year he returned to his job in Wath where one day, in 1792, when he was just twenty, he saw an advertisement in the *Sheffield Register* for a clerk on the newspaper. Montgomery applied and secured the post.

The owner and editor of the *Sheffield Register*, Joseph Gales, was an outspoken radical who supported the French Revolution. Under threat of prosecution by the government, he fled to the United States, leaving Montgomery in charge, not now just a clerk and journalist, but editor and eventually proprietor. Within a year, Montgomery's inexperience got him in trouble with the authorities. He published on the newspaper's presses a ballad which was deemed to contain seditious sentiments ('... should France be subdued, Europe's liberty ends, If she triumphs the world will be free.') and he was tried at Doncaster quarter sessions in January 1795, fined £20 and imprisoned for three months in York Castle. Within a year of his release, he was in prison again at York Castle, this time for six months. This was for libel following his highly critical report on Col Althorpe's leadership of the Volunteer Militia when they dispersed a large crowd that had gathered

Photograph of Ian's great-grandmother, reputably framed by Charlie Peace (*d.* 25 February 1879).

Police mugshot of Charlie Peace.

in Norfolk Street around a group of volunteer privates, who were complaining about their pay being withheld. They shot at and killed two men, and wounded several others.

However, Montgomery returned to Sheffield and to his newspaper. He had renamed it the *Sheffield Iris* and remained editor for thirty-one years, eventually retiring in 1825. In those thirty-one years, he mounted long-term campaigns in its columns against slavery and against 'the barbarous and abominable practice' of employing young boys and girls to climb up and clean soot-filled chimneys. He wrote poetry all his life, all of it now forgotten. The early verse written shortly after he came to Sheffield was of a political nature, railing against government corruption and the failure of the Established Church to minister to the working-class population. His longer poems such as 'The Wanderer of Switzerland', 'The West Indies' (celebrating the abolition of slavery) and 'The Pelican Island' came out in several editions and were widely read in this country and abroad. When the poet laureate Robert Southey died in 1843, Montgomery's name was mentioned in the same breath as William Wordsworth as a possible successor. In 1836, he was rewarded for his services to poetry when Prime Minister Robert Peel placed him on the Civil List with a pension of £200 per annum. In the same year, William Wordsworth sent Montgomery a new edition of his collected poems, the dedication beginning 'In admiration of genius...' He was also a prolific hymn writer ('the Christian poet') of 355 hymns in all. Some of these still appear in modern hymn books, the best known being the carol 'Angels from the Realms of Glory' which made its first appearance in the *Sheffield Iris* on Christmas Eve in 1810. He died in 1854.

Did You Know That?

One of our more infamous Sheffield residents of the late nineteenth century was cat-burglar and murderer Charlie Peace, whose criminal activity led to notoriety in Victorian England. He did however pursue various legitimate trades, one of which was as a picture framer.

6. Getting About in Sheffield

Sheffield has an interesting history of transport and transportation, much linked to its hilly terrain and the city being at the centre of a confluence of six valleys. Other factors contribute as well, with Sheffield's air pollution being so famously bad that (according to Stewart Rotherham), in the 1950s, the paint for buses and trams was tested in Sheffield to see how it coped with the corrosive atmosphere. If it survived here then it was fit for purpose and could survive anywhere! There are other peculiar quirks too, like the fact that in the 1970s, it was suggested that Sheffield had the greatest density of Rolls Royce cars in the UK. Remarkably too, always a centre for active countryside recreation such as walking, Sheffield has emerged as a place for cycling also, but of course, especially for those seeking hills, spills, and thrills of steep inclines.

Packhorses and Medieval Motorways

In medieval and early industrial times, it is fair to say that roads were mostly in desperately poor condition. With the exception of a few former Roman roads with militarily straight, engineered precision, most routes were dirty, muddy, windy tracks. Travel was generally by foot, by horse, by cart or for the more affluent, by carriage. In this context, commercial transport of goods was done by teams of packhorses travelling across the countryside along established routes that were mostly unmetalled, unflagged, and unmaintained. With teams of packhorse ponies bearing panniers carrying materials and goods, the jaggers (as the drovers were known), led their beasts up hill and down dale. Drovers were also called packmen, badgers and swailers. As a track became wet, slippery, eroded and unpassable, they simply moved laterally across the hill. When the situation deteriorated further, they did the same again and the process resulted in what we call 'braided hollow-ways', still visible in the landscape today on the western moors of Sheffield. These were the medieval motorways and many ran from the Cheshire salt-fields; salt being a hugely important commodity in pre-refrigeration medieval England. As they came down the hill into Sheffield, they would converge once again into a few primary routes into the town at the confluence of the Rivers Don and Sheaf. Roads such as Psalter Lane with its 'salt' name bear testimony to its medieval origins. Beyond Sheffield and to the east, the packhorse trails extended to ports such as Bawtry or south towards Nottingham.

For some wet and boggy routes, the solution to transport was through a causeway. The problem caused by sinking into a bog or slipping down a steep, wet slope was partly solved by building causeways (locally causeys), lines of flagstones about 2 feet wide. Part of a causey still survives in Shroggs Wood at Ecclesfield.

Turnpikes and Tollgates

By the 1700s, it was realised that there was a crisis in transportation and that this affected not only individual mobility and comfort, but importantly, commercial activities.

Sheffield's roads were rutted, pitted and potholed, and indeed virtually impassable; does this sound familiar? Something had to be done, and one solution was to establish toll-roads or turnpikes, often straight, roadways laid out by surveyors and engineers, and today frequently mistaken for the lines of so-called Roman roads. The word 'turnpike' refers to an earlier practice of using a bar full of spikes to bar the way. It would be lifted to allow access. These roads were paid for by tolls collected by a gatekeeper at a toll bar and/or a toll cottage or toll house. Toll houses are often easily recognised because of their shape with big windows facing up and down the road. An example is the so-called 'Round House' at Ringinglow, which of course is not really round but octagonal. It is the best known in the Sheffield area but had only a short life in this capacity – from 1795 to c. 1825. The design enabled the custodian to look out for traffic on the three roads that it controlled by two gates. Other famous 'bars' include that at Hunter's Bar at Endcliffe.

Traffic on these toll roads was charged according to the value of the goods transported and the potential damage they might do to the surface of the highway. With a major industry in the manufacture of grindstones to the west of Sheffield, the rolling of the cut and prepared stones in massive groups caused havoc and was charged accordingly. Traditionally, children or poor people were paid a pittance to collect and grade suitable stones to infill ruts in the road.

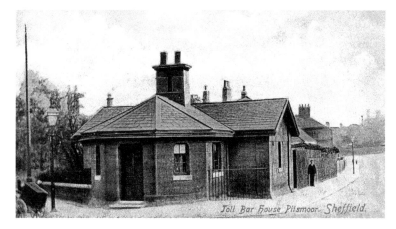

Pitsmoor toll house.

The Roundhouse and Norfolk Arms at Ringinglow, Sheffield, in the early 1900s.

For travellers to find their way in all weathers across moorlands the first waymarkers were piles of stones at crossways and then in the eighteenth century the first guide stoops appeared. These were stone posts just a few feet high with pointing fingers, the names of market towns and other settlements and on later ones the mileages to those places.

There is much direct evidence for the existence of turnpike roads still surviving. At various points along a number of local former turnpike roads are the mileposts. One such example is a milepost on the former Rotherham, Wortley and Four Lane Ends Turnpike; the trust running this turnpike being created in 1788 and dissolved in 1883. This milepost survives at Burncross in northern Sheffield on the now A629. It boldly gives the name of the trust and states that in one direction Chapeltown is 1 mile away and Rotherham 6 miles away, and in the other direction Penistone is 8.5 miles way.

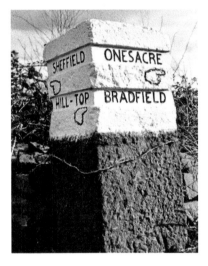

Finger post at Onesacre.

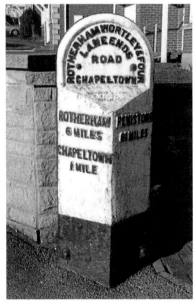

Milepost on the Rotherham, Wortley & Four Lane Ends turnpike.

McAdam to the Rescue with Macadam Road Surface

A new system for building roads was pioneered in France in the mid-1700s. This practice was adopted by Scottish engineer Thomas Telford who took the idea of raising the road slightly above the surrounding land to reduce waterlogging problems. He also adopted the use of good quality stone, with the whole structure built on a base of flagstones.

However, the final step towards Sheffield's road surfaces today came via another Scotsman, John Loudon McAdam, born in Ayr, Scotland in 1756. He realised that the massive roads of stone upon stone were unnecessary if the basic structure was carefully planned, graded and executed with consistent quality and smaller stones. Other engineers took McAdam's approach further when it was realised that infilling the gaps between the stones with fine dust enhanced the surface, known as water-bound macadam. This system needed a lot of manual labour but produced strong, free-draining roadways. Such roads were described as 'macadamized', but better was still to come.

As motor vehicles came to the fore in the early 1900s, the dust generated on macadam roads became a serious problem. Low air pressure was formed by fast-moving vehicles (travelling at dizzy speeds of 20 or 30 mph!), sucking dust from the road surface. This meant the town's roads were covered with dust clouds and the road surface itself was falling apart. However, the invention of what we now call 'tarmac' transformed all this when in March 1902, a Swiss doctor in Monaco called Ernest Guglielminetti applied tar from the local gasworks to bind the dust. Edgar Purnell Hooley mixed coal tar and ironworks slag patented as tarmac, and finally in the 1920s, modern mixed asphalt (in the US called 'blacktop'), with aggregate mixed into the tar before it was laid, was perfected. The modern road system of Sheffield depends almost entirely on this system, but it is worth searching out the surviving Victorian and Georgian areas of the urban centre to see the wonderful cut cobbles or setts. These came with the added problem, as discovered in Paris, that they made wonderful ammunition for rioters and those of a revolutionary disposition!

The general idea of tarmac caught on and each location used the products most easily available to them, usually by-products of industry. What many Sheffield people will not know is that a road dressing and tar macadam called Duroid was made in Sheffield,

Duroid advertisement by W. Heath Robinson.

manufactured at Smithy Wood Coking Plant between Chapeltown and Ecclesfield by Newton Chambers. The coke ovens opened in 1929 and closed in the mid-1980s. The tar was a by-product of the production of coke (until 1943 for the Newton Chambers blast furnaces). An advertising booklet published in 1932 on the occasion of a visit to the coke ovens by members of the Highways Surveyors' Association of the West Riding of Yorkshire explained that 1,200 tons of coal were carbonized each day, producing as a by-product 10,800 gallons of tar. The tar was used in a wide variety of Duroid products including Duroid spraying grade, heavy Duroid spraying grade, Duroid mixing grade, Duroid Hotmix and Duroid grout.

The Arrival of the Canal

The town of Sheffield is situated on the River Don at its confluence with the River Sheaf, but a combination of size of the river channel and the flow of water, together with industrial weirs every so often, meant that the upper reaches of the river were not navigable. Therefore, as Sheffield emerged as a centre for tool manufacture in the medieval period, goods had to be transported overland to the nearest inland port of Bawtry on the River Idle. As time passed, the lower reaches of the River Don were made navigable, but even so, boats could still not reach the centre of Sheffield; a major disadvantage for the import of raw materials and the export of manufactured goods.

There had been proposed canalisation projects to join Sheffield to the navigable River Don as early as 1697, but these were never implemented. The river became navigable at Tinsley, thence to the Rivers Ouse and Trent, and to the great Humber Estuary and eventually the North Sea. From 1751, the canal terminus had been at Tinsley.

Weir on the River Don at Beeley Woods in the 1920s.

The old lock-keeper on the canal at Tinsley.

However, by 1815, an Act of Parliament formed the Sheffield Canal Company with a recommended route to leave the River Don at Jordan's Lock, opposite where the 'Holmes Cut' of the Don Navigation joined the river and follow the north side of the Don Valley to a basin 'in or near Savile Street'. This favoured route proved unfavourable to one of the main sponsors, as the Duke of Norfolk's estate realised it would not pass beside its collieries at Tinsley Park and Manor. The alternative route was to follow the south side of the Don Valley, terminating at a canal basin on what had been the orchards of Sheffield Castle. The new route needed two series of locks. One lock was at Tinsley to raise the level from the River Don and a second one was at Carbrook, to provide the height necessary to flow into the town centre.

On 7 June 1815, with 182 subscribers, an Act of Parliament was passed, the Duke of Norfolk (£2,000) and the Earl Fitzwilliam (£1,000) being the largest contributors for the scheme costing £76,000. Work was overseen by civil engineer William Chapman and Hugh Parker of Woodthorpe Hall laid the first stone on 16 June 1816. The canal opened in 1819 with a crowd of 60,000 people and a flotilla of ten barges arriving from Tinsley, one carrying coal from Handsworth Colliery, the first cargo on the new canal. The opening of the Canal Basin was greeted with great enthusiasm in the town and a fleet of barges festooned with flags and with bands playing on the decks made a triumphal entry into the Canal Basin. Today the Sheffield and Tinsley Canal is a quiet waterway for mainly recreational craft, with the canal-side banks populated by dog walkers and fishermen.

The Railways Come to Sheffield

The first line to open was the railway to Rotherham in 1838, followed by a trans-Pennine railway in 1845. The latter was the Manchester–Sheffield stretch of the Manchester, Sheffield & Lincolnshire Railway. This line terminated in Sheffield in 1845 and was extended to Grimsby in Lincolnshire in 1847.

Designed by architect Charles Trubshaw, the Sheffield Midland Railway Station was opened in 1870 by the Midland Railway, becoming the fifth and last station built in Sheffield town centre. It was constructed on the 'New Line' running between Grimesthorpe Junction (on the former Sheffield and Rotherham Railway), and

Midland Station Sheffield M&S

Sheffield Midland Station in the early 1900s.

Tapton Junction, just north of Chesterfield. The new line replaced the Midland Railway's earlier route, the 'old road', to London, from Sheffield Wicker and south via Rotherham.

The new line and station faced both controversy and local opposition since the Duke of Norfolk, the major local landowner, was insistent that the southern approach was hidden in a tunnel and an area known as 'The Farm' be landscaped to screen the development. The tunnel was later converted into a deep cutting. One controversy, which remains today, was the provision of public access across the site so that Sheffield centre was not cut off from its population to the south. For the route west, the building of the Totley Tunnel created the fourth-largest railway tunnel in the country.

Sheffield's other main central railway station was the Sheffield Victoria, the main railway station on the Manchester, Sheffield & Lincolnshire Railway. The railway line is commemorated in the Wicker Arches, which was the main access route to the station. The main goods yard was at Bridgehouses, now mostly subsumed in the new road network at the bottom of Spital Hill and Savile Street. Although the later Midland Station grew in status with the route south to London, the Victoria was significant because of electrification for freight purposes after the Second World War, taking the Woodhead Route named after the long Woodhead Tunnel. The Victoria Station and the Woodhead Line became casualties of the Beeching Review and closed in favour of the Hope Valley Line via the Totley Tunnel, which was slower (not electrified) but served more settlements on its journey westwards.

Horse Trams in Sheffield

The Sheffield horse tramway was created under the Tramways Act 1870, with powers granted in July 1872. The first routes, to Attercliffe and Carbrook, Brightside, Heeley, Nether Edge and Owlerton opened between 1873 and 1877. Under the legislation at that time, local authorities were precluded from operating tramways but were empowered to construct them and lease the lines to an individual operating company. The tracks were constructed by contractors and leased to the Sheffield Tramways Company which operated the services.

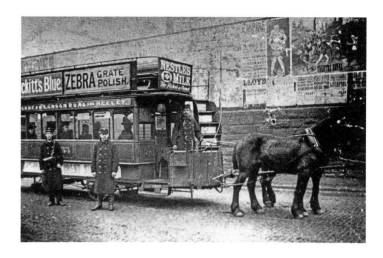

A Sheffield horse tram.

Prior to the inauguration of the horse trams, horse buses had provided a limited public service, but road surfaces were poor and their carrying capacity was low. The new horse trams gave a smoother ride. The fares, however, were too high for the average worker and services began later than when workers began their day and so they were of little use to most. Running costs were high as the operator had to keep a large number of horses and could not offer low fares.

It was common practice to paint tramcars in different colours according to the route operated. This helped illiterate people to identify the trams.

At this time, when Sheffield was powered by manpower and horses, littering the vast number of animals in the expanding town would have been a major problem. A little-known fact is that they were probably littered with peat cut from the vast raised bog of Thorne Moors near Doncaster. This same site provided huge amounts of peat litter for the warhorses on the Western Front in the First World War.

Electric Trams and Supertram

Sheffield Corporation (now Sheffield City Council) took over the city's tramway system in July 1896. The Corporation's goal was to expand and mechanise the network, so almost immediately a committee was established to inspect other tramway systems to consider improved traction. The committee recommended adopting electrical propulsion using an overhead electric current collection system. However, the National Grid was not yet developed as it is today and the Corporation needed to generate its own power to service the demand. In order to achieve this, the Corporation became the local generator and supplier of domestic and industrial electricity. To this end, a power station was established between Mowbray Street and Alma Street on Kelham Island, adjacent to the River Don. Feeder cables carrying electricity extended from the power station throughout the system – over 40 miles of tramway.

The horse tramlines remained but the tracks replaced with heavier rails, and as lines opened to expanding suburbs at Abbeydale, Walkley and Hunter's Bar, the connecting link between Moorhead and Lady's Bridge in the central network was also laid. Electric-powered trams opened successively with Nether Edge to Tinsley on 6 September

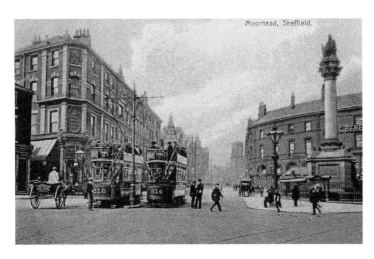

Moorhead in the early 1900s.

1899, a route to Walkley on 18 September 1899, and to Pitsmoor on 27 September 1899. Others soon followed. By 1905, the full network of electric trams was pretty much in place across the city, though later additions included extending routes out from the city and connections between main lines.

The trams lasted until the late 1950s with the final route, from Beauchief to Vulcan Road, closing on the afternoon of Saturday 8 October 1960. For this significant event, there was an illuminated tramcar with passengers and council dignitaries that ran from Beauchief to the Tinsley depot. Following the lead vehicle was a procession of fourteen trams each of which proceeded to Tinsley or Queens Road – the end of an era. Sheffielders can still pay homage to the illuminated tramcar now preserved at the Crich Tramway Museum in Derbyshire.

However, by the early 1990s, with city-centre traffic problems and increasing concerns about air pollution, the tram returned, but this time as Supertram. Construction took place from 1991 to 1995 and combined with the impacts of the Thatcher Government's deregulation of public transport systems, brought much of Sheffield centre and some of the affected suburbs to an unpredictable standstill. When it was opened, just thirty-five years on from the old tramway network closure, it brought the city a state-of-the-art transport system but sadly with just three main routes. In 2015, the city celebrated twenty years of the Supertram system.

The Simplex Car

Sheffield has never been famed for motor vehicle manufacture, but with one slight exception. The Sheffield-Simplex business was a car and motorcycle manufacturer that operated from 1907 to 1920 based in Sheffield and in Kingston-upon-Thames, Surrey. The company had financial backing from the local-to-Sheffield aristocrat and coal baron, the Earl Fitzwilliam. Peter Brotherhood made the original cars following on from the Brotherhood-Crocker cars manufactured in London with Earl Fitzwilliam as an investor. Stanley Brotherhood then sold the London site in 1905 and moved the Peter Brotherhood business to Peterborough, near Fitzwilliam's second seat at Milton Hall. However, when he failed to gain permission to build his car factory in Peterborough, Fitzwilliam suggested a move to Sheffield, the new

factory, built in Tinsley, just a few miles south of the Fitzwilliam residence at Wentworth-Woodhouse. After all, Sheffield made the steel, so why not the cars too.

Business fortunes improved during the First World War, when the company made armoured cars for the Belgian and Russian armies, together with ABC Wasp and Dragonfly aircraft engines, and like other Sheffield factories, munitions. Post-war, the cars continued to be manufactured into the 1920s, but success was limited and the company

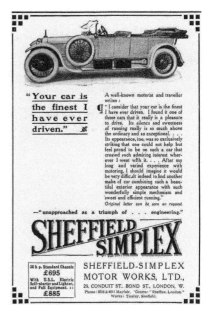

Right: The Sheffield Simplex – 'Your car is the finest I have ever driven' and 'unapproached as a triumph of engineering'.

Below: The Sheffield Simplex armoured scout car in 1916 with a young Viscount Milton.

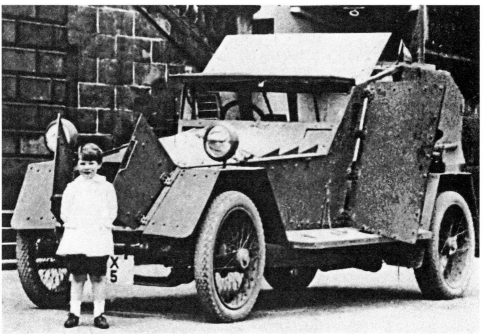

was liquidated in 1925. In total, Sheffield's motor industry produced about 1,500 vehicles, from which just a few remain as sought-after collector's items.

The Hole in the Road

Many buildings around Sheffield's markets and Fitzalan Square were damaged or destroyed on the night of 12 December 1940, when the Luftwaffe bombed the city during the Sheffield Blitz. The bombsites were cleared of rubble and debris, but a lot remained empty for years. However, in 1968 many old streets and the surviving buildings were demolished to make way for the new Arundel Gate, a dual carriageway that ended at a large roundabout built on the site of the former medieval market place. Along with motor traffic, the roundabout addressed the issue of pedestrians, and this was the era of the modern subway and Sheffield as always, wanted the biggest and best; The 'Hole in the Road' was born. To separate pedestrians and vehicles, underneath the roundabout was constructed a network of underpasses and shops with the core being a circular space open to the sky. Officially called 'Castle Square' it was soon affectionately known as 'T' Ole in t' Road' or the 'Hole in the Road'. Indeed, it was soon felt by many to be a significant city landmark, but like much urban design of the time did not wear well. By the early 1990s, the 'Hole' was rather sad and dilapidated having lasted from 1967 until 1994, it was infilled, according to some, with rubble from the then recently demolished Hyde Park Flats. Then in 1994, as a major part of the redesign of Sheffield centre, and linked to works on the new Supertram network the roundabout was removed and the whole area landscaped. All three routes of the Supertram call at Castle Square tram stop.

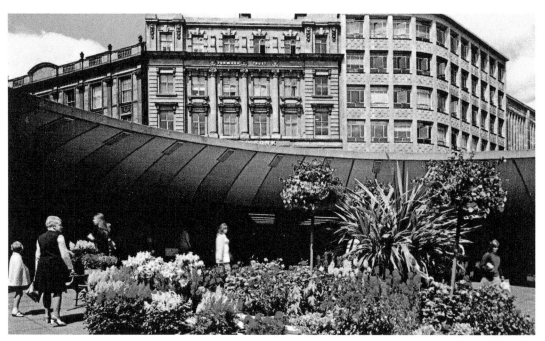

The Hole in the Road in the 1970s.

All mod cons at the M1 – The Grill and Griddle, Fortes, Woodhall Services near Sheffield in 1971.

The Motorway Comes to Town

The M1 motorway runs north–south to connect London to Leeds, at which point it now joins the A1 (M). This was the first inter-urban motorway completed in Britain and mostly opened between 1959 and 1968. Constructed in four phases, the M1 is 193 miles (311 km) long with the southern end extended in 1977 and the northern section by Leeds, in 1999. A little-known fact is that the original M1 route was intended to end at Doncaster but with a 'Leeds and Sheffield Spur'. However, this was revised to make the Sheffield/ Leeds section the primary route and the eleven-mile (18-km) route to the A1 (M) south of Doncaster became a separate motorway, the M18.

Opened in March 1968, at a cost of £6 million, the Tinsley Viaduct is a two-tier road bridge and was the first of its kind in Britain. It carries the M1 and the A631 for over 1,000 metres across the Don Valley, from Tinsley to Wincobank. In the process of crossing the valley, it passes over Sheffield Canal and Midland Mainline railway. The Sheffield Supertram runs alongside part of the viaduct on the trackbed of the former South Yorkshire railway line from Sheffield to Barnsley. However, the viaduct has had problems and almost endless repairs. Built as low-cost, steel box girders, the structure was quite novel but became controversial following three serious disasters in 1970, when box-girder bridges collapsed in high winds. One result was a lengthy and expensive programme of strengthening for the Tinsley Viaduct.

Sheffield Takes Off: A Short History of Sheffield Airport

Sheffield City Airport was a short-lived, short-runway, small airport on the eastern outskirts of Sheffield but is now closed. The site, which opened to passengers in 1997, was on the former site

of the ancient deer park at Tinsley. Tinsley Park spent a number of centuries as coal bell-pits, a deep coalmine, and then a major steelworks with associated landfill and other operations. The site is near the M1 motorway and Sheffield Parkway and remarkably, sections of the ancient woodbanks or park boundary still survive though in part cut through by the parkway. The airport was constructed on derelict, contaminated land that was first opencast mined for coal and to clean up the resulting area. It was a short STOLport runway like the one at London City Airport. Initially, flights were offered to Belfast, Amsterdam, Brussels, Dublin, Jersey and London with the airlines KLM UK, Sabena, British Airways, and Aer Arann. Remarkably, in view of the airport's ultimate fate, the Amsterdam service was described by KLM UK as their best ever start-up. They had passenger figures of 46,000 in 1998, 75,000 in 1999, 60,000 in 2000, and 33,000 in 2001. However, with key services lost the available destinations became very limited and numbers plummeted to 13,000 in the final year of operation.

Though shrouded in controversy, the airport's CAA licence was withdrawn on 21 April 2008 and it officially closed on 30 April 2008. On 22 November 2012, the South and East Yorkshire Branch of the Federation of Small Businesses launched a campaign and petition to delay redevelopment of the airport site, requesting the potential and viability to be reassessed. Nevertheless, Sheffield City Council approved plans to turn the airport into a business park; even so, a mystery bidder had offered to reopen the airport. Interestingly, by the time the airport closed, the developers of the rather bizarrely named Robin Hood Doncaster Sheffield Airport owned the site; Tinsley was then more valuable to them as a business park than as an airport. Today the site is a hugely important advanced technology park.

Of course, there had been earlier proposals, in 1968, to build an airport near Todwick in Rotherham or on the massive peat bog at Thorne Moors near Doncaster, but these lapsed. The reason for the absence of an airport in Sheffield is the simple lack of an area of suitable flat land. The claimed intention had been to open in time for the 1991 World Student Games, but that was never realistic. The Doncaster site never really stacks up as a 'Sheffield' airport, and so the controversy lingers still.

A flight from the short-lived Sheffield Airport at Tinsley in the 1990s.

7. Sheffield's Countryside

Sheffield has an enormous variety of accessible countryside – public parks, ancient woodland, wooded river valleys, hill farmland, low-lying farmland, and open moorland. The most famous quotation about Sheffield – that no one can find the origin of – is that it was 'a dirty picture in a golden frame'. Most of the golden frame (29,640 acres – 11,995 hectares) lies within those parts of the parish, later the borough and then the city that are included in the Peak District National Park. Moreover, it has its own 'lake district' to the west and north-west of the city where the valleys are occupied by reservoirs.

Sheffield's 'heritage' public parks – of which there are more than a dozen – encircle the city 'like pearls on a necklace' as one writer described them. They vary in age from the pre-Victorian (the Botanical Gardens) to the early Victorian (Norfolk Park) after which there was a gap of nearly thirty years followed by a steady succession of park openings: Firth Park, Weston Park, Endcliffe Park, Meersbrook Park, Hillsborough Park and Whiteley Woods. The City Council also continued to acquire new parkland in the twentieth century through gift and purchase, for example Millhouses Park, Graves Park and Whirlow Brook Park. In addition, after local government reorganisation in 1974, even more parks were added from outlying parts of the city.

However, perhaps Sheffield's greatest and most unexpected green assets are the eighty ancient woodlands dotted about the city. What other British city can match this statistic? The answer is none. Sheffield is the best-wooded city in the country. Moreover, both resident and visitor are almost always aware of the woods in the landscape as they cover the scarps and back slopes of the highest ridges, and on lower ground they hang on steep valley sides to the very heart of the urban area. All these countryside sites have fascinating stories and histories.

Norfolk Park

The 70-acre (28 hectares) Norfolk Park, on land given by the Duke of Norfolk, opened in 1848, and was the first Sheffield park that the public could use free of charge. The park contains Victorian park lodges, avenues of lime and turkey oak, and an area of ancient woodland. There are splendid views of the city from the site. In the 1990s, the Friends of Norfolk Park joined with the City Council to work on a bid to the Heritage Lottery Fund and an award of £2.4 million was made, together with additional money from other funding partners to total £4.7 million for restoration work. The park now boasts a new community building with meeting rooms, restored lodges, and new playgrounds. It is listed by English Heritage as a Grade II park landscape because of its historical value as an early Victorian example of a public park.

Weston Park

Weston Park was created from the grounds of Weston Hall, an early nineteenth-century house built by eminent Sheffield sawmaker Thomas Harrison. His two daughters

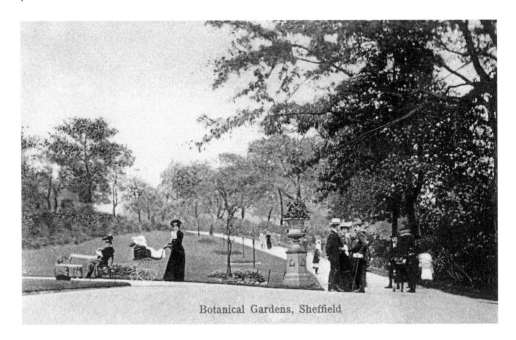

Botanical Gardens, Sheffield

Sheffield Botanical Gardens in Edwardian times.

inherited the Weston Hall estate and on their death, Sheffield Corporation bought it for £18,000. Robert Marnock, who had designed the Sheffield Botanical Gardens and who in 1840 became curator of the Royal Botanical Gardens in Regent's Park, London, modified the grounds for use as a public park. The hall became Sheffield's first museum. The park and museum were officially opened in September 1875, the *Sheffield Daily Telegraph* reporting that the park 'was thronged by a well-behaved and highly delighted crowd. The weather was fine. The park looked in its gayest summer dress'. The site was remodelled in 1935 and has recently undergone extensive refurbishment financed by the Heritage Lottery Fund. Besides its outdoor recreational role, Weston Park contains a number of interesting and well-loved historic features, including the park gateway, a monument to Godfrey Sykes, a statue to the Ebenezer Elliott, the 'Corn Law Rhymer', the York and Lancaster Regiment war memorial, and a magnificent bandstand. Another well-known feature of the park is the weather station at which rainfall and temperatures are recorded daily; one of the longest running local weather stations in the country. The modest but rather old and attractive glasshouse was sadly demolished.

Endcliffe Park

Endcliffe Park in the Porter Valley, formerly known as Endcliffe Woods, was acquired by Sheffield Corporation in 1885 and the layout designed by William Goulding. He was a nationally acclaimed park designer who kept, as instructed, as much of the semi-natural landscape as possible. The parkland and informal greenspace in the Porter valley now extends westwards through Bingham Park, Whiteley Woods, and Porter Clough, to Ringinglow and the moors beyond. A special feature in Whiteley Woods is Shepherd Wheel, a restored water-powered industrial site dating back to 1584.

Waterfall at Endcliffe Woods,
around 1910.

Meersbrook Park and Bishop's House

In 1886, Sheffield Corporation purchased the land on which Meersbrook Park stands to
prevent it from being acquired for housing and to provide something more than just a
place in which to promenade. Meersbrook House formerly held the Ruskin Collection
and was known as the Ruskin Museum, and since the 1970s until very recently was the
headquarters of the City Council's Parks Department. Originally, it included an ornamental
rose garden, a rockery with a cascade walk in an area known as The Glen, crossed by
a rustic bridge. However, these attractions have now mostly been lost. Nevertheless,
the park is still an attraction with wonderful panoramic views across the city, a walled
garden, which provides training and volunteering opportunities, and Bishops' House
Museum, a timber-framed house built around 1500 for a yeoman farmer/scythemaker.
Both inside and out, the wonderful timberwork of the building can be examined at
close quarters. The old bandstand has gone but some other Victorian features remain.
It was at Meersbrook, before the modern-day park, that Charles Dixon pioneered British
birdwatching – through binoculars rather than collecting the skins of shot birds. Harold
Armitage wrote of the bark strippers and tanners leaving the great oaks naked and bare
before the trees were felled in Rushdale just below today's park in the 1800s, the area
being described as the most beautiful glade outside of Chatsworth.

The Ruskin Museum at Meersbrook House, *c.* 1905.

Meersbrook Park, 1907.

The old bandstand in Hillsborough Park.

Hillsborough Park

This park was originally the grounds of Hillsborough House, built in 1779 for Thomas Steade. In the nineteenth century, it was successively in the ownership of John Rodgers of Joseph Rodgers & Sons, cutlery manufacturers, and the Dixon family of the silverware and silver-plating company. Sheffield Corporation bought Hillsborough Park (excluding the hall) in 1890 and opened it as a public park in 1892. In 1903, the hall was also purchased and opened as a branch library. The lake in the park, an enlarged version of the original lake, was used for boating until around 1960. It is now a haven for wildlife and used for fishing. A special feature of the park is the walled former kitchen garden. Work to restore this was begun by volunteers in 1991. The garden was reopened by the Duke of Kent on 15 April 1993, the anniversary of the Hillsborough stadium disaster in which ninety-six football supporters lost their lives. A memorial garden within its walls commemorates them.

Abbeyfield Park

Together with its house, this park is situated a couple of miles from the city centre. The house, built in the 1840s for a local colliery owner, was first called Pitsmoor Abbey, but by 1852 it passed to the Wake family along with the grounds and was renamed Abbeyfield House. Sheffield City Corporation acquired the site as a public park in 1909, and in the 1930s and 1940s, the park still had a boating lake, which has now been filled in. The park also had a giant chess set, as well as a bowling green and other amusements.

Graves Park

Graves Park, based on the ancient Norton Park, lies 3 miles south of the city centre and was until relatively recently in north Derbyshire. This is the largest park in Sheffield – 205 acres (83 hectares) and the size, its character with wide-open spaces, woodlands and water, make it a tranquil place in which to relax. The urban area with hundreds of thousands of people seems far away. Today's municipal open space is the descendant of a medieval park, landscaped early in the nineteenth century for Samuel Shore, a Sheffield banker. He also rebuilt Norton Hall in 1815. In 1925, Alderman J. G. Graves presented the park to the people of Sheffield and it was further enlarged in 1932 and 1935. Graves Park has a formal sunken rose garden which was created in the 1930s, three woods (Cobnar, Summerhouse, and Waterfall), a refreshment pavilion and three lakes. It has a Family Farm, which incorporates a rare breeds' centre with Tamworth pigs, Highland cattle, Jacob's sheep, rare donkeys, red deer, and, famously, a very large eagle owl. The park itself holds many surprises such as an Iron Age burial mound, an ancient historic spring, medieval fields and an ancient deer park, plus now hidden, the once main road south to Chesterfield.

Whinfell Quarry Gardens

Discretely hidden off the main Sheffield to Fox House road, Whinfell Quarry Gardens near the entrance to Whirlow Brook Park is an ornamental garden created in 1898 as part of the extensive grounds of Whinfell House. When Samuel Doncaster, notable local industrialist, had the house built he commissioned the firm of James Backhouse and Son from York Nurseries to supply the plants for the new garden. The derelict flagstone quarry in the western suburb provided an ideal microclimate to grow rare and exotic plants. The garden has steeply winding paths and steps, a few rock pools and some rare plants, shrubs and trees. The specimens include bamboo, giant gunnera, redwoods, weeping beech, cedars, maples, flowering cherries, rhododendrons and conifers. In 1912, Clarence Elliott, a nationally acclaimed British horticulturalist, plant hunter and nurseryman, was commissioned to design the smaller quarry as a limestone rock garden. Here many alpines, shrubs, deciduous trees and conifers were planted. Industrialist Frederick Neill purchased the house from Samuel Doncaster in 1933 and in 1968, the gardens were presented to the city by James Neill Holdings Ltd as a memorial to Sir Frederick Neill.

Ecclesall Woods

Ecclesall Woods is the largest area of ancient woodland in Sheffield, covering nearly 300 acres (121 hectares). The site is so extensive it would be possible to take a walk through the woods once a week for a year taking a different route each time. In the medieval period the woods were a deer park, but by Elizabethan times they were coppice woods, with this management continuing until the mid-nineteenth century. Under threat of development in the 1920s, they were purchased by the City Council from Earl Fitzwilliam in 1927. The woods are full of archaeological features including charcoal hearths, whitecoal pits, prehistoric cup and ring carvings, a major hillfort (discovered by Paul Ardron in the early 2000s), Romano-British fields, and even a monument to a charcoal maker who burnt to death in 1786.

Ancient trackway through
Ecclesall Woods, Paul Ardron.

Concord Park, its Cruck Barn and Woolley Wood

In 1929, Alderman J. G. Graves presented Concord Park, adjacent to Woolley Wood, to
the city; the site was subsequently enlarged in 1932. Its most remarkable feature is its
cruck barn, called Oaks Fold Barn. In a survey of 1637, the Oaks Fold Barn was described
as 'a Barne of five bays', a bay being the space between each pair of cruck blades. The
cruck blades are on full view inside the barn. Outside the barn is a carved wolf to mark
the fact that the name of Woolley Wood, which lies next to the park, means 'a clearing
frequented by wolves'. Woolley Wood was first mentioned in a document written about
1600 when it was referred to as 'Woolley Woode Springe', a spring wood being coppice-
with-standards. In this kind of wood, most of the trees were periodically cut down to
ground level to what is called a stool and from this grew multiple poles (the coppice)
that 'sprang' from the cut tree. Some of the trees were not coppiced but allowed to grow
on to become single-stemmed trees and these were the standards. Wild cherry is more
common in Woolley Wood than in any other local woodland and its beautiful blossom
is a great attraction in late April. The wood is also a wonderful bluebell wood with
carpets of intense blue in late April and May. The scarce hawfinch feeds in the wood on
hornbeam nutlets.

Interior of the cruck barn in Concord Park.

Bowden Housteads Wood

This woodland was first mentioned in a document in 1332, making it one of the earliest recorded ancient woods in Sheffield. Located at Handsworth, it was purchased in 1916 by Sheffield Corporation from the Duke of Norfolk. In the 1930s, as part of a job-creation scheme for unemployed workmen, an outdoor swimming pool was built in part of the wood where it is cut by the Car Brook. The swimming pool had silted up by the 1950s; its approximate location is now beneath the roundabout off the main Sheffield Parkway to the Mosborough Parkway. During the 1940s, a large lozenge-shaped area was shallow opencast for coal under the wartime emergency energy measures. In the 1970s, the wood was cut in two by the building of the Sheffield Parkway, for many years the main link road from the M1 to the centre of Sheffield. Further inroads resulted from the Mosborough link-road, and finally in 2015, the construction of a fire station within the woodland. A sculpture of a giant steelworker carved by Jason Thomson stands by the side of the wood next to the Sheffield Parkway inbound road at Handsworth.

The Steel Giant in Bowden Housteads Wood.

Holly and Holly Hags

During the long cold winters of medieval England, food for grazing animals was a serious concern and for half the year or more, little grass grew in northern shires. Because of this, holly hags, special enclosed woods of holly, were once important features of the wider farming countryside around Sheffield where they were used as fodder for sheep and for deer in deer parks until at least the eighteenth century. A medieval record in the Sheffield area occurred in 1442 when the Lord of Hallamshire's forester at Bradfield noted in his accounts payment for holly sold for animal fodder in winter. John Harrison in his survey of the Manor of Sheffield in 1637 recorded twenty-seven separate 'Hollin Hagges' that were rented by farm tenants from the Earl of Arundel. The use of holly as fodder in the Sheffield area was also graphically described by two early diarists. In 1696, Abraham de la Pryme wrote that:

> In south-west Yorkshire at and about Bradfield and in Derbyshire they feed all their sheep in winter with holly leaves and bark, which they eat more greedily than any grass. To every farm there is so many holly trees ... care is taken to plant great numbers of them in all farms hereabouts.

Twenty-nine years later, in 1725, a party headed by the Earl of Oxford travelled through Sheffield in a south-easterly direction across an area of common land called the Burley Hollins. It was noted that they travelled:

> through the greatest number of wild stunted holly trees that I ever saw together. They extend themselves on the common for a considerable way. This tract of ground that they grow upon is called the Burley Hollins... [They have] their branches lopped off every winter for the support of the sheep which browse upon them, and at the same time are sheltered by the stunted part that is left standing.

The question that naturally arises is, do any of these holly hags still survive in the landscape? Writing in 1977 two local researchers, Martin Spray and Dennis Smith, believed that there were at least the remains of five holly haggs in the country to the west of Sheffield. They mention Fox Hagg and Coppice Wood in the Rivelin Valley, the holly bushes still surviving at Holly Edge and at Holly Busk near Bolsterstone and a location near the edge of Loxley Common. Numerous other holly-rich ancient woods have since been identified and evidence of former holly haggs is still found in local place names. For example, Hollinsend, Hagg Side, Hollin Bank, and the Holly Bush public house which is near to the area of the 'Burley Hollyngs' on Birley Moor.

While the use of holly for fodder declined, in the nineteenth century the local market gardeners and tree nursery at Handsworth (Fisher, Son and Sibray) bred several varieties of Holly for commercial production. One in particular is the Handsworth Holly that has been exported across the world but which can still be seen around the local area in gardens and hedges. A little-known fact is that in Ecclesall Woods, while the natural wild holly grows there, the more frequent one is a garden escape, the Highclere Holly with less prickly leaves – spread from local gardens by defecating thrushes!

Shire Brook Valley

The Shire Brook, in the southeast of Sheffield, runs eastwards from Gleadless Townend to Woodhouse Mill where it joins the River Rother. It forms part of an historical boundary stretching back over 1,000 years. The stream marked the division between the ancient kingdoms of Mercia and Northumbria, part of the same boundary running along the Meers Brook and at Dore. This was the boundary between Yorkshire and Derbyshire, until 1967 when Sheffield expanded its boundaries and the area south of the Shire Brook around Beighton and Hackenthorpe became part of Sheffield. By this time, much of this area was already covered by residential developments built to accommodate Sheffield's growing population. This process had started in the 1930s with the building of the Frecheville Estate by Henry Boot & Sons Ltd. The houses were owned by a subsidiary of Henry Boots, the First National Housing Trust Ltd and rented out at a cost of between 10s (50p) and 12s (60p) per week, the roads named after places in the Derbyshire Peak District. In the 1950s, Sheffield City Corporation started developing the area now covered by the Hackenthorpe Estate, where many road names reflect industrial heritage and old place names of the Shire Brook Valley. The Birley East Colliery and the local sewage works dominated the opposite side of the valley at Woodhouse. There was also a colliery railway branch-line from the junction at Woodhouse to the coal yard on Birley Moor Road. The line crossed Coisley Hill and looped round the back of Normanton Springs to Linley Lane. None of this line remains, although the trackbed from Coisley Hill along Stone Lane is part of the

The hidden Shire Brook Valley looking over towards Woodhouse, Peter Wolstenholme.

Trans-Pennine Trail. Today, the central part of the valley is a Local Nature Reserve with a visitor centre in the former 1930s office building of the Coisley Hill Sewage Works.

Birley Spa

Now hidden within the large Hackenthorpe Estate, in south-east Sheffield, is Birley Spa, formerly part of the extensive Birley Moor, common land for Beighton parish. A natural spring supplies water high in minerals to a bath house, which dates back to 1842. This was when the site was developed as a hotel and spa by Earl Manvers, lord of the manor of Beighton. It is clear that Birley had a reputation for its waters long before that, being mentioned in a book on the mineral waters of England in 1734. The spa is located in a steep-sided wooded valley through which the spring originally flowed and there are still traces of ancient woodland in the grounds, which were replanted and developed with a boating pond below the hotel. The single-storey hotel building was in the Dutch style with the bathhouse underneath. Originally, there were two baths at the spa, a marble one and a stone one, the latter surviving to this day. Earl Manvers sold the spa in 1913 and the new owners developed it into a public pleasure ground with rowing boats, swings and seesaws. Tea and hot water were also provided and entry was 2*d* for adults and a penny for children, with swimming in the spa bath for sixpence. The origin of the spring has not been traced but its flow through the spa bath area continues constantly. It formerly ran down the valley into the dam at Carr Forge and then to the Shire Brook.

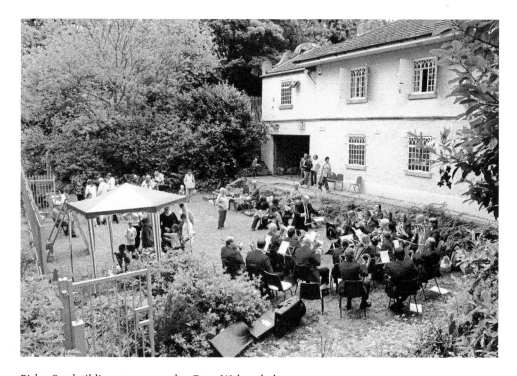

Birley Spa building, 2005 open day, Peter Wolstenholme.

Bath in basement at Birley Spa, Peter Wolstenholme.

Did You Know That?

The word 'spring' in the woodland names Ladies Spring, Wilson Spring and Low
Spring has nothing to do with water? It is an Old English word for a managed wood.
In the Sheffield area, a spring was coppice-with-standards in which most trees were
periodically cut down to ground level and then 'sprang' back as multi-stemmed trees.

National Park Pioneers

The idea of creating a National Park in the Peak District was born and nurtured in
Sheffield. On 7 May 1924, a select gathering of like-minded men and women disturbed
by the increasing defacement of the beauty of the Peak District by 'incongruous and
promiscuous development', met at Endcliffe Vale House in the quiet western suburbs of
Sheffield. They had come together to discuss the possibility of forming a society for the
protection of local scenery. The founder members present at the first meeting were a
cross section of Sheffield's leading citizens. The Honorary Secretary elected at the initial
meeting was Mrs Ethel Gallimore, widowed during the First World War, and who had
instigated the meeting. Ethel Gallimore was not only the founder but also the inspiration
and prime mover of the new society, which was initially called 'The Sheffield Association
for the Protection of Local Scenery'. In 1927, the society became affiliated to the Council

for the Protection of Rural England and in 1930 became the 'Sheffield and Peak District Branch of the CPRE'. By 1936 a young architect, Gerald Haythornthwaite, had joined the branch as secretary and remained for the next fifty-nine years, having married Ethel Gallimore in 1937. Together, Mr (later Colonel) and Mrs Haythornthwaite, masterminded the achievement of the branch's two 'grand purposes', the creation of a Sheffield Green Belt and the designation of the Peak District as a National Park. The Peak District National Park became a reality in 1951 and a third of the total land area of Sheffield is within its boundaries.

The countryside in the Peak Park within Sheffield city boundary is part of the 'Dark Peak' landscape zone, an extensive area of semi-natural, wild countryside. The area is composed of exposed bleak plateaux with dramatic gritstone edges on the highest parts of the Millstone Grit country. Large stretches are covered by heather moorland and blanket bog, without a sign of habitation. These windswept moors contain valuable wildlife habitats in the boggy mires and flashes. Deep narrow valleys carrying fast-flowing river headwaters fringe the area, sometimes heavily wooded on the steep valley sides. Some of these narrow valleys are called cloughs, while others contain in their names the place-name element 'den', meaning a long, narrow, curving valley as in Ewden (yew-tree valley) and Agden (oak valley). At lower levels on the eastern margins are pastures enclosed by drystone walls and used mainly for sheep rearing.

Gerald Haythornthwaite.

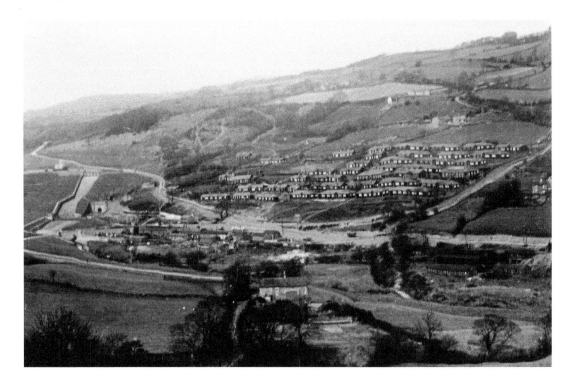

Ewden Valley and the 'Tin Town' Village, from Frank Harvey.

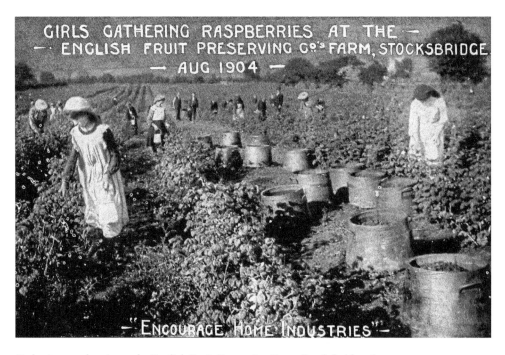

Gathering raspberries at the English Fruit Preserving Farm, Stocksbridge, August 1904.

The Ewden Valley and Broomhead Reservoir

The larger valleys contain reservoirs built in the late nineteenth and early twentieth centuries to provide water for the ever-expanding industrial and residential areas of Sheffield. Broomhead Reservoir in the Ewden Valley, north-west of Sheffield, was constructed in 1934. This large reservoir covers 50 hectares and contains more than 1,000 million gallons of water. Today it is a popular recreational area with only a few signs of the so-called 'tin town' temporary village and railway built to accommodate the workers who constructed the reservoir, and their families. The village at Ewden had its own mission church, recreation hall and pub as well as a shop, and was lived in until the 1960s.

Redmires Reservoirs and Wyming Brook

The Redmires Reservoirs lie just within the western boundary of Sheffield and on the eastern fringe of the Peak District National Park in the upper Rivelin Valley west of the suburb of Fulwood. They lie at an altitude of 1,150 feet (352 metres). There are three reservoirs at Redmires: Upper, Middle and Lower. Middle reservoir was completed in 1836, Lower reservoir in 1849 and Upper reservoir in 1854. The reservoirs are fed by streams from the surrounding Hallam Moors, which apart from conifer plantations nearby, consist of unimproved grassland, moorland and blanket bog. The area is popular with walkers, sightseers, and ornithologists, the latter because the reservoirs form an important breeding ground for waders and wildfowl. The reservoirs are on a 'visible migration' route in spring and autumn.

The Man's Head Rock, Rivelin Valley, Sheffield, around 1906.

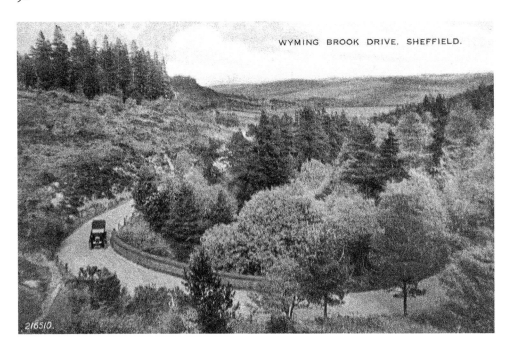

WYMING BROOK DRIVE, SHEFFIELD.

Above: Wyming Brook Drive in the 1940s.

Left: Wyming Brook by Joseph Dyson, written in 1925.

WYMING BROOK.

(BY JOSEPH DYSON.)

Wyming Brook! Thou lovely glen!
Alone with thee and God, again
I see thy beauty more and more,
Thy charms inspire, and I adore.
This, God's Temple seems to be,
It is "The House of God" to me;
Paradise was perfect bliss—
Eden must have been like this!
If my soul on fire could be,
And harp Æolian tuned by me;
Enrapt I would thy beauties tell,
This is like Heaven—thou lovely dell!
The rocks so rough, so old, so grey,
Who formed them, and how old are they?
These massive blocks all down the glen,
How came they here? I wonder when.
And this clear brook by night and day
Murmurs, as it glides away;
The trees, and ferns, and moss, and grass,
Are lovely all along the pass.
The silence makes the haunt like Heaven,
The murmur—heavenly music given;
Every object gilt with light
Is perfect beauty, pure and bright.
The splendour here no tongue can tell.
Methinks, God here must always dwell!
God dwells—thank God—with all mankind,
Wherever living men you find.
God blesses men where'er they be,
God's love for ALL is full and free;
This glen is concentrated bliss!
What must be Heaven—compared to this?
August 8th, 1925.

From its source at the Redmires Reservoirs, Wyming Brook falls steeply in a north-easterly direction for three-quarters of a mile (just over 1 kilometre) into the lower of the two Rivelin Dams. The valley occupied by Wyming Brook is wooded with a mixture of native broadleaves, mostly birch with some willow carr, and planted larch and pine. Wyming Brook has long held a spell over Sheffielders and a network of paths and trackways was constructed for people to stroll along, and earlier to take carriage rides. Because of the steep gradient and the rock-strewn streambed, the water flow can be dramatic as it dashes down rocky rapids in the narrow ravine. The area is now a nature reserve managed by Sheffield Wildlife Trust.

Toad's Mouth

The Toad's Mouth, a natural gritstone boulder resembling the mouth of a toad, stands at the roadside on the A625 between Sheffield and Hathersage, right on the boundary between South Yorkshire and Derbyshire. Close inspection of the boulder shows that at some point in the past, how distant in the past no one knows, a round eye has been carved into the face of the toad.

Carl Wark and Higger Tor

Carl Wark and Higger Tor both lie in the Burbage Valley, right on the western boundary of the city of Sheffield and within the Peak District National Park. They are massive outcrops of millstone grit, isolated through faulting. Loose flat boulders lie on the upper surface of the outcrops with others at the foot. The separation of these blocks from the outcrop occurred during the last glaciation when the area lay just outside the ice-covered regions of an Arctic climate. Exposed to the chill air the rocks were subject to intense

Higger Tor and Carl Wark, a striking feature in Sheffield's beautiful frame.

freeze-thaw conditions, which split them apart. As the climate ameliorated at the end of the cold period, and the ground thawed, many loose blocks simply slid onto lower ground. Because of Carl Wark's shape and steep rocky walls on three sides, it was occupied as a 'fort' in Iron Age times. Whether this was a defensive site, or more likely, a significant meeting place, is unknown. Today because of their altitude both of these outcrops make wonderful viewpoints; Higger Tor stands at 1,254 feet, or 384 metres.

Did You Know That?

In the early eighteenth century, and possibly for centuries before, there was a manorial rabbit warren on Loxley Common. Rabbits were greatly prized for their fur and meat. In the early 1720s, there are records of rabbit burrows being made and repaired on Loxley Common. Private rabbit warrens were bounded by great banks or thick stone walls topped by gorse. Towards the eastern end of the common, there are still surviving double stone walls filled with soil and rubble. Other notable warrens were at Wharncliffe (where the forester wrote a handbook on rabbit warrens) and at Broomhead Hall in the Ewden Valley.

Historical Timeline for Sheffield

8,000–3,000 BC: The earliest evidence of human beings in the Sheffield area at a Mesolithic camp of hunter-gatherers near Deepcar.

500 BC: Iron Age hillfort on Wincobank Hill was likely destroyed.

AD 54: Roman fort was established at Templeborough in the lower Don valley.

830: The Northumbrians submitted to King Ecgbert of Wessex at Dore.

1086: The manor of Sheffield was named and described in the Domesday Book.

1173–76: Beauchief Abbey was established.

1270: A stone castle was built to replace the earlier Norman motte-and-bailey castle.

1296: A royal charter was granted for a market every Tuesday.

1297: Tax returns mention a cutler in Sheffield.

c. 1390: Chaucer mentions a 'scheffield thwitel' in his Canterbury Tales.

1486: Lady's Bridge, northern entrance to the town, was built in stone.

1503–1510: The Hall in the Ponds was constructed.

1570: Mary, Queen of Scots, was brought to Sheffield Castle in captivity.

1624: The Company of Cutlers of Hallamshire came into being.

1637: Sheffield deer park still contained 1,000 fallow deer.

1692: Sheffield's population estimated to be around 5,000.

c. 1740: Benjamin Huntsman developed crucible steel.

1786: Steam power first applied to the cutlery grinding process.

1819: Sheffield Canal was opened, terminating at the Canal Basin.

1832: Cholera epidemic claimed the lives of 402 Sheffielders.

1838: The first railway line reached Sheffield.

1848: Norfolk Park, the first public park with free access to the general public was opened.

c. 1850: The beginning of the colonisation of the Lower Don Valley by the heavy steel industry.

1858: Henry Bessemer opened his steel works in the Lower Don Valley.

1870: Sheffield ('Midland') railway station opened with a direct route to London.

1873: The first horse-bus route opened.

1875: Edward, Prince of Wales, opened Firth Park.

1893: The Lyceum Theatre was built.

1897: Queen Victoria officially opened Sheffield's new Town Hall.

1905: University of Sheffield founded.

1910: The Electra Palace, Sheffield's first purpose-built cinema opened.

1913: Harry Brearley discovered stainless steel.

1914: Sheffield parish church became Sheffield Cathedral.

1931: Sheffield's population rose to over half a million.

1932: The building of the City Hall was completed.

1940: Sheffield Blitz.

1951: The Peak District National Park was opened with one-third of the land area of Sheffield within its boundaries.

1960: Park Hill high-rise residential development was completed.

1965: The 21-storey Arts Tower at the University of Sheffield was opened.

1968: The Tinsley Viaduct on the M1 Motorway was opened.

1971: The Crucible Theatre was built.

1982: Kelham Island Industrial Museum was opened.

1990: Meadowhall Shopping Centre was opened.

1991: World Student Games were held in Sheffield.

1992: Sheffield City Polytechnic became Sheffield Hallam University.

1997: Sheffield Airport opened.

2002: The Winter Garden opened.

2008: Sheffield Airport closed.

2014: On 6 July, Stage 2 of the Tour de France finished in Sheffield.

Bibliography

Addy, S. O., *The Evolution of the English House* (George Allen & Unwin: London, 1898).

Anon., *Illustrated Guide to Sheffield* (Pawson & Brailsford: Sheffield, 1862).

Armitage, H., *Chantrey Land* (Applebaum: Sheffield, 1910, reprinted 1998).

Barraclough, K. C., *Sheffield Steel* (Moorland Publishing Company Ltd: Ashbourne, 1976).

Bownes, J. S., Riley, T., Rotherham, I. D. and Vincent, S. M, *Sheffield Nature Conservation Strategy* (Sheffield City Council: Sheffield, 1991).

Bunker, B., *Portrait of Sheffield* (Robert Hale: London, 1972).

Burngreave Local History Group, *Pitsmoor: A Peek into the Past* (Burngreave Messenger: Sheffield, 2012).

Derry, J., *The Story of Sheffield* (Sir Isaac Pitman & Sons Ltd: London, 1915).

FABCO Local History Group, *Around the Nab* (Wildtrack Publishing: Sheffield, 2006).

Gatty, A., *Sheffield Past and Present* (Thomas Rodgers, Bell & Sons Ltd: London, 1875).

Hall, T. W., *A Descriptive Catalogue of Sheffield Manorial Records from 1424 to 1624* (J. W. Northend: Sheffield, 1934).

Handley, C. and Rotherham, I. D., *Moor Memories in the Bradfield, Midhope and Langsett Areas* (Wildtrack Publishing: Sheffield, 2011).

Handley, C., Stapleton, B. and Rowles, A., *Shire Brook: The Forgotten Valley* (ALD Design & Print: Sheffield, 2007).

Hey, D., *A History of Sheffield* (Carnegie Publishing: Lancaster, 1998).

Hunter, J. (1819) Hallamshire: the History and Topography of the Parish of Sheffield. (revised by A. Gatty, Virtue & Company, 1873), Sheffield and London.

Jones, J. and Jones, M., *The Remarkable Gatty Family of Ecclesfield* (Green Tree Publications: Sheffield, 2003).

Jones, M., *Protecting the Beautiful Frame* (The Hallamshire Press: Sheffield, 2001).

Jones, M., *Sheffield: A History & Celebration* (Francis Frith Collection: Salisbury, 2005).

Jones, M., *Sheffield's Woodland History*, 4th edition (Wildtrack Publishing: Sheffield, 2009).

Jones, M., *The Making of Sheffield* (Wharncliffe Books: Barnsley, 2004).

Leader, R. E., *The History of the Company of Cutlers in Hallamshire* (Pawson & Brailsford: Sheffield, 1905).

Pollard, S., *A History of Labour in Sheffield* (Liverpool University Press: Liverpool, 1959).

Rotherham, I. D., *Lost Sheffield in Colour* (Amberley Publishing: Stroud, 2013).

Smith, A. H., *Place-names of the West Riding of Yorkshire: Part 1* (Cambridge University Press: Cambridge, 1961).

Stainton, J. H., *The Making of Sheffield* (E. Weston & Sons: Sheffield, 1924).

Vickers, J. E., *A Popular History of Sheffield* (EP Publishing Ltd: Wakefield, 1978).

Walton, M., *Sheffield: Its Story and Its Achievements* (The Sheffield Telegraph and Star Limited: Sheffield, 1948).

Wilson, R. E., *Two Hundred Precious Metal Years: A History of the Sheffield Smelting Company Limited 1760–1960* (Ernest Benn Ltd: London, 1960).

Woodhead, S. and Jones, M., *Sheffield: A Photographic Journey Through Yorkshire's Greenest City* (Myriad Books Ltd: London, 2009).